THE ART
OF THE
BOOKPLATE

Get **more** out of libraries

Please return or renew this item by the last date shown.
You can renew online at www.hants.gov.uk/library
Or by phoning 0845 603 5631

 Hampshire
County Council

THE ART
OF THE
BOOKPLATE

JAMES P. KEENAN

Foreword by George Plimpton

BARNES
&NOBLE
BOOKS
NEW YORK

THE ART OF THE BOOKPLATE

For information contact:
Silver Lining Books, 122 Fifth Avenue, New York, NY 10011
212 633-4000

Barnes & Noble and colophon are registered trademarks.

Publisher:	Barbara J. Morgan
Editorial Director:	Margaret Mathews-Berenson
Design:	Richard J. Berenson
	Berenson Design & Books, Ltd., New York, NY
Production:	Della R. Mancuso
	Mancuso Associates, Inc., North Salem, NY

Library of Congress Cataloging-in-Publication Data is available on request.

ISBN 0-7607-4696-6

Printed in Canada

First Printing

CONTENTS

THOUGHTS OF A BOOKPLATE LOVER
George Plimpton

I HAVE ALWAYS ADMIRED BOOKPLATES. An occasional book borrowed from a lending library will still have one affixed on the inside front cover, and before I dip into the contents, I try to guess from its designs, letters, heraldic figures, and curliques something about the former owner. I would suppose that everyone who reads has at some point designed, perhaps doodled, a bookplate of sorts. I have done so—a composition that includes balls, bats, racquets (to designate my interest in sports), the *hadada ibis* (bird-watching), a rocket (fireworks), a bicycle (I go everywhere in New York on one), and finally, a center boss that displays the emblem of the *Paris Review*, the literary magazine I have edited for over fifty years—an American eagle wearing a French revolutionary cap standing on a quill-like pen. I never did anything about this, of course (tossed it into the wastepaper basket), but I can see the composition in my mind's eye.

Very likely the first bookplate I saw was my grandfather George Arthur Plimpton's. A publisher by trade (Ginn & Co.), he was a prodigious collector—everything from antiphonals to wooden cigar store Indians. His main interest was in educational matters. In a short book entitled *The Education of Shakespeare*, he once wrote of his vast collection (much of it donated to Columbia University), "I had the privilege to get together the manuscripts and books which are more or less responsible for our present civilization because they are the books from which the youth of many centuries have received their education."

In his collection were twenty-four hornbooks: the paddle-shaped

learning implements that children carried about in Shakespeare's time to learn their ABCs—a kind of primer mounted on wood, protected by a thin slice of transparent horn, and with a handle like a hand mirror's. Children carried them on their belts and, I have no doubt, took them off to whack apples and such into the next orchard or at each other.

Hornbooks were the pride of my grandfather's collection. He was fond of pointing out that while he possessed twenty-four, J. P. Morgan, a fellow collector, only had one!

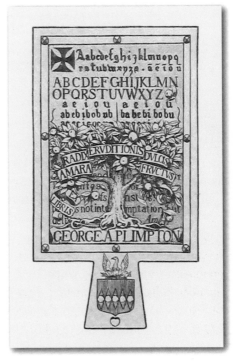

GEORGE ARTHUR PLIMPTON
American (1855-1936)

No wonder then that my grandfather's bookplate was shaped like a hornbook (pictured above). Readers will note the ABCs in different scripts, the vowels (a e i o u), and then the vowels linked, for reasons I do not know, with the letter B. The main figure in the bookplate is a very fruitful tree of knowledge. Part of the Lord's Prayer peeks out from behind the trunk. I have no idea why "temptation" was on my grandfather's mind when he designed the bookplate. Bookplates tell you something about their owners but not, thank goodness, too much.

As for the bookplates themselves, what is to be known about them is wonderfully divulged in what follows.

New York City, May 2003

THE ART OF THE BOOKPLATE

BOOK LOVERS LOVE BOOKS in different ways. They may arrange them in a very particular fashion; they may dialogue with the author by making notes as they read; they may amass their books in numbers far beyond shelving capacity. But there is one trait that all book lovers seem to share: When they lend a cherished book to a friend, they hope their friend will enjoy it—but most of all, they hope to get it back.

To ensure a book's eventual return, some owners will write their name in the front of the book, others will use a rubber stamp or an embosser. And then there are those truly devoted book lovers who will affix their own personalized bookplate as the ultimate safeguard for the book's return.

In addition to marking ownership, the bookplate, or ex libris, symbolizes the owner's pride in the possession of books. Mark Severin, a twentieth-century Belgian bookplate engraver, said that "a book without a [book]plate is, to me, like a child waiting to be adopted. A man really loving a book wants to tighten his bonds with it, to honor it and to treat it with respect. He wants to show that he has had it as a friend and to make it that much different from other copies of the same volume. . . ."

The words ex libris are taken from the Latin, meaning "from the books of" or "from the library of." The ex libris is usually pasted on the inside of the front cover of a book. It is a personal statement, a reflection of the owner's tastes and interests.

In addition to giving the owner's name, sometimes a simple phrase is added:

From the Books of Selva Hernandez

Ex Libris—Tyrone S. Davis

George Uchida—My Book!

Others carry warnings, mottoes, and quotes:

Stolen from John H. Henry III

A jolly goode booke,
Whereon to looke
Is better to me than golde.

━━━━

Any one may borrow,
But a gentleman returns.

━━━━

If you borrow, freely use it,
Take great care and don't abuse it:
Read, but neither lose nor lend it,
Then unto the owner send it.

━━━━

Steal not this book for fear of shame,
For here you see the owner's name.

━━━━

Go ye rather to them that sell and buy for yourselves.

━━━━

If through respect or love I lend
This book unto my worthy friend,
He must not soil, abuse, nor tear,
But read with diligence and care;
And when its contents you have learned,
Remember, it must be RETURNED.

A Japanese bookplate dating back to 1470 carries an especially powerful warning:

To steal this book closes the gates of heaven,
And to destroy it opens the gates of hell.
Anyone who takes this book without permission
Will be punished by all the gods of Japan.

While the wording on bookplates varies greatly, so also do their designs. Some are straightforward and utilitarian, just a plain label bearing the owner's name. Others may feature extraordinarily

complex compositions—impressive works of art in miniature. Subject matter ranges widely from heraldic designs with coats of arms, to portraits, landscapes, or objects and scenes symbolizing the owner's profession or interests. Techniques employed to produce the bookplates vary widely too: woodcuts and wood engravings, engraving on metal, silk screens, etchings, and lithographs. Bookplates are generally printed on fine archival-quality papers. Most are printed in small quantities, according to the owner's specifications. Some are hand-colored or customized with calligraphy, pen and ink, and watercolor.

Many have been designed by important artists and engravers. Among some familiar names are Albrecht Dürer, William Hogarth, Thomas Bewick, Paul Revere, Kate Greenaway, Aubrey Beardsley, Marc Chagall, Maxfield Parrish, M. C. Escher, Rockwell Kent, Leonard Baskin, and Barry Moser. Most of these bookplate artists are acknowledged for their work as fine artists, book illustrators, printmakers, and graphic designers.

The list of distinguished patrons who have collected books and commissioned bookplates covers all periods since the fifteenth century. Prominent names include Queen Victoria, George Washington, Paul Revere, Herbert Hoover, Eleanor Roosevelt, John F. Kennedy, Charles de Gaulle, J. P. Morgan, Harpo Marx, Claire Boothe Luce, Enrico Caruso, Sigmund Freud, Anita Loos, Walt Disney, Albert Einstein, and Charles Dickens, to name merely a few.

Although marks of ownership have been identified in early-tenth-century libraries of Egypt and Asia, the first known bookplate dates back to the mid-fifteenth century. German in origin, it is believed to have been commissioned by Johannes Knabensberg, also known as Igler, a name

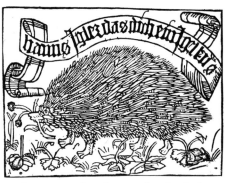

Johannes Knabensberg—"Igler" bookplate

derived from the German word for hedgehog. Rendered as a woodcut, it depicts a hedgehog and includes an inscription within a banner. The Igler bookplate would have been placed in precious handwritten manuscript books. To warn against theft, Knabensberg printed a stern warning—"Hans Igler that the hedgehog may kiss you"—and the first known bookplate was created. Only a few hand-colored copies exist today.

In approximately 1450 Johannes Gutenberg revolutionized the world of books with his invention of printing from moveable type. As a result books became more readily available throughout Europe and were affordable to many more people. Soon collectors acquired sufficient volumes to justify commissioning their own bookplates. By 1480 German ex libris were much in evidence among the upper classes. Primarily simple woodcuts, they featured heraldic designs incorporating the owner's coat of arms. Some of the foremost artists in Europe—Albrecht Dürer, Lucas Cranach the Elder, Hans Holbein, and others—created these early armorial bookplates. Printed in black ink, a few were hand-colored.

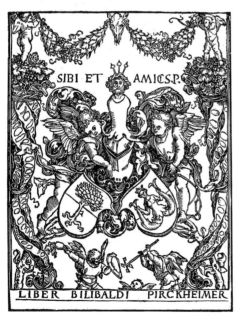

Albrecht Dürer bookplate

In 1516 Albrecht Dürer (1471-1528) created the first bookplate to include a date. Dürer executed no fewer than twenty bookplates, mostly for his friends. His detailed ornamental style, incorporating heraldic motifs with decorative borders of garlands, allegorical figures, and architectural elements, established the standards that eventually

evolved into the highly decorative, grand armorial style of the period.

Copperplate engraved bookplates appeared around 1525. Copper is a soft metal that allows for highly detailed hand engraving, thus affording artists greater freedom to execute graceful flourishes and embellishments.

Until the mid-sixteenth century, book and art collecting in Europe had been limited to royalty and the upper classes. With the growth of an affluent and educated middle class, book collecting came into vogue. The books of this period were masterfully produced, utilizing hand-set text combined with copperplate engraved illustrations. With increasing activity and interest in the book arts, the craze for personalized bookplate designs was well under way.

∾ THE GOLDEN AGE OF THE BOOKPLATE

The eighteenth century is known as one of the finest periods for bookplate engraving. This golden age introduced works by many well-known artists, including William Hogarth—whose decorative heraldic style exhibited superb craftsmanship. The majority of bookplates at this time, as in earlier years, were armorial, although some depicted

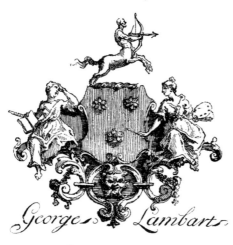

William Hogarth bookplate

mythological or allegorical figures as well as scenic landscapes. A typical English bookplate of this period might include a panoramic view of the owner's castle or country estate, or a nearby church. Animals and birds appeared frequently, especially if the owner's name was related to the creature. George Hawks's bookplate, for example, included an elegant hawk perched in the

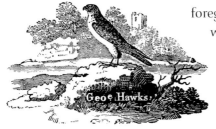

foreground of an idyllic landscape with a high stone tower looming in the distance. In vogue at this time, too, were designs indicating a person's profession or avocation: drafting tools for architects, musical instruments for composers, musicians, or music lovers,

George Hawks' bookplate

and scales of justice for attorneys. Referred to as pictorial bookplates, these formal, elegant, and exquisitely detailed ex libris reveal a great deal about their owners' lives.

≈ BOOKPLATES IN THE AMERICAS

Among the earliest known examples of marks of ownership in the Americas are fire marks or brands. First used by monks in convents in Nueva España (now Mexico) during the sixteenth century to identify books in their possession, fire marks were burned along the edge of the text pages with a hot branding iron, leaving the indelible mark of a figure or symbol that characterized the order of the convent. Fire

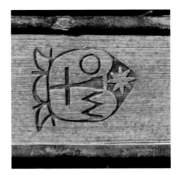

Fire mark burned onto edge of text pages

marks were replaced in the eighteenth century with printed ex libris. The main sources of inspiration for these early bookplate designs were the bookplates found in European books that were brought to Mexico by early settlers.

Bookplates came to Colonial America in the mid-seventeenth century in the books of the earliest English and Dutch settlers. The earliest dated ex libris in the New World was printed in 1642 by Stephen Daye (1594-1668). Daye, a Massachusetts Bay colonist,

operated the first printing press in the New World at Harvard College and is considered by many to be the first printer in the American colonies.

The majority of American bookplates from the Colonial period, however, were produced by engravers in England for the prominent families of the South. These bookplates incorporated the then popular family coats of arms. In contrast, early settlers of the northern colonies, particularly those who had fled political or religious persecution in the Old World, harbored an aversion to all symbols of aristocracy and were uninterested in heraldic bookplates.

As the colonies grew and prospered, a few industrious native engravers in the northern colonies began to produce their own bookplates. Important engravers of this period include Nathaniel Hurd, Peter Rushton Maverick, Paul Revere, and Henry Dawkins.

CLASSIFICATION OF BOOKPLATE DESIGN

During the last half of the nineteenth century, bookplate collecting became increasingly popular. Ushered in with the Victorian era and its growing population of educated bourgeoisie who enjoyed keeping scrapbooks and memorabilia, bookplates were viewed as desirable collectibles. Serious collectors found a valuable resource in J. Leicester Warren's 1880 book, *A Guide to the Study of Bookplates*, the first reference book to designate a classification system for ex libris, making it possible for collectors to determine dates. In 1894, Charles Dexter Allen's *American Bookplates: A Guide to Their Study with Examples*, was published. It divided early armorial bookplates into four basic styles: Early English, Jacobean, Chippendale, and Ribbon & Wreath.

The Early English style incorporates the owner's coat of arms with elaborate mantling surrounding three or four sides of the shield. The date, the name of the owner, his title, and sometimes his address are included. Very few examples of this style remain, though a fine one is the plate for Joseph Dudley.

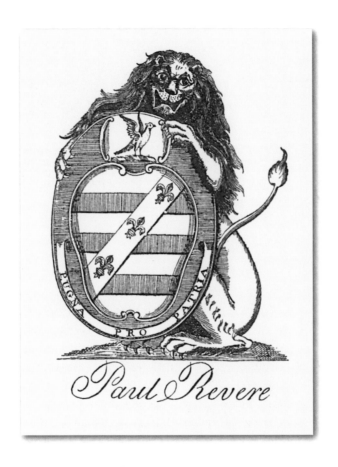

PAUL REVERE
American (1735-1818)
Boston silversmith, engraver, and Revolutionary hero, Paul Revere is best known for his famous midnight ride of April 18, 1775, celebrated in a poem by Henry Wadsworth Longfellow, to warn of the British advance on Lexington and Concord. His bookplate incorporates the motto, "Pugna pro patria" —"I fight for my country."

The Jacobean style is generally seen in bookplates designed from 1700 to 1745. These plates are ornate and formal, with evenly balanced, symmetrical designs in exacting proportions. Heraldic shields are rectangular in shape, frequently set over an elaborate frame. Backgrounds often incorporate either a fish-scale pattern or brick wall motif. Imagery may also include an abundance of armorial references from family crests to helmets, as well as scallop shells, fruit, animals, birds, and heavy scrollwork that resembles carved wood.

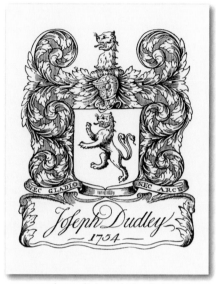

Early English-style bookplate

Jacobean-style bookplate

Chippendale-style bookplates first appeared in 1745 and remained popular until about 1790. The name no doubt derives from the "ornate and flowering spirit" that the English furniture maker Thomas Chippendale introduced into wood carving and upholstery of this period. The light, expressive designs offered a pleasing contrast to the heavier, formal motifs of their Jacobean predecessors. Chippendale plates exhibit a

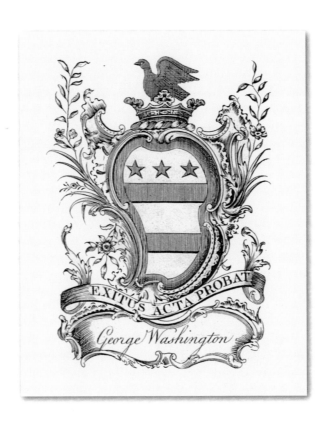

George Washington
American (1732-1799)

Many U.S. presidents followed the lead of our first president and commissioned their own bookplates. George Washington's Chippendale-style, heraldic plate interestingly features a crown. The Latin motto translates as "The result justifies the deed."

marvelous combination of scrolls, flowers, and other decorative embellishments.

By 1790 the Ribbon & Wreath style dominated. Consisting of simplistic designs utilizing a spade-shaped shield, unsupported, devoid of background detail, these bookplates incorporate flowing, banner-like ribbons and various floral wreathing motifs.

Ribbon & Wreath-style bookplate

✐ BOOKPLATES IN THE NINETEENTH AND TWENTIETH CENTURIES

At the turn of the nineteenth century costly copperplates gave way to a revival of wood engraving, and an innovative process was developed in which the design was cut into the end grain of the wood block rather than the face. This resulted in a technique that not only allowed greater detail but was less costly than metal. British artist Thomas Bewick (1753-1828) perfected this white-line engraving, marked by closely spaced white lines that define the subject matter. Many wood-engraved bookplates of Bewick and his followers portray romantic themes, elegant heraldic motifs, and complex landscapes. These techniques were

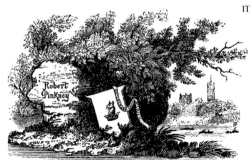

Thomas Bewick bookplate

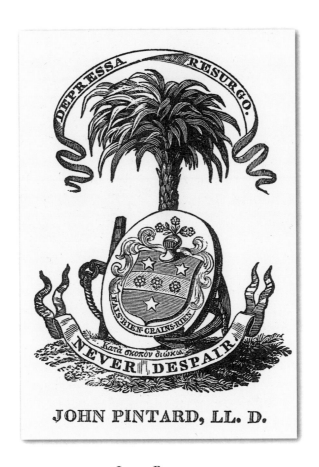

JOHN PINTARD
American (1759-1844)

*One of the finest examples of wood-engraved bookplates by Alexander Anderson (1775-1870),
America's first wood engraver, this pictorial ex libris includes the admonition, "Do well, fear
nothing," in French—an appropriate motto for Pintard, one of New York City's most accomplished
and civic-minded citizens. Founder of the New York Historical Society and the American Bible
Society, he was also involved in New York politics as the first city inspector and later as state
assemblyman. Through a family legacy, he inherited an interest in the China and East India
trade. The palm tree towering over his coat of arms on this ex libris is an obvious reference to
Pintard's investments in exotic tropical lands. His bookplate dates sometime after 1822 when
Allegheny College bestowed upon him the honorary degree of L.L.D. or Doctor of Laws.*

Charles William Sherborn bookplate

also employed by Alexander Anderson (1775-1870), considered to be the first American wood engraver. Although Anderson engraved only seven known bookplates, he was a prolific artist whose finely detailed wood engravings appeared in numerous books and on many banknotes throughout his lifetime.

While the use of armorial designs predominated during the seventeenth and eighteenth centuries, pictorial bookplates also proliferated at this time and continue to be popular today. The range of subject matter seems almost unlimited. Portraits, library interiors, stacks of books, landscapes, and allegorical subjects are common.

Steel engraving became popular in the mid-nineteenth century. Although much harder to engrave than copperplate, steel affords the artist crisp lines and is especially durable for large-quantity press runs. Engraving on both copper and steel continued into the late nineteenth and early twentieth century by such masters as Charles William Sherborn and George W. Eve in England.

❧ THE "LITTLE MASTERS"

In the United States, Edwin Davis French, Sidney Lawton Smith, Arthur Nelson Macdonald, William Fowler Hopson, and J. Winfred Spenceley became known as the Little Masters of copperplate

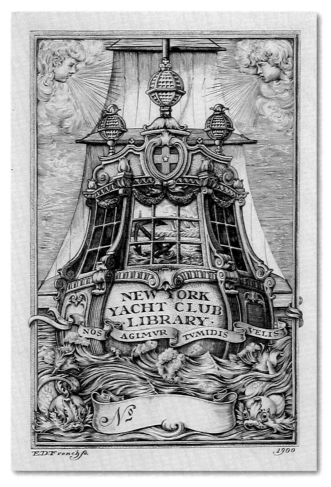

NEW YORK YACHT CLUB

Founded in 1844, the New York Yacht Club not only provides a sanctuary for sailing enthusiasts while in the city, but also organizes regattas and races for its members around the world. The club's ex libris is typical of E.D. French's elegant compositions. Rich in nautical detail, it includes the ornate stern of a sailing vessel plowing through the sea as two wind spirits blow it forward toward the next port. In the foreground sea creatures flank a banner that will record the number of the book for the library's records. This same motif is also incorporated on the façade of the landmark building in Manhattan designed by Whitney Warren and Charles Wetmore in 1901. The motto, "We go forward with swelling sails," conveys a welcoming message to every sailor at sea.

engraving. They produced exquisite designs that employed vignettes and ornamentation reminiscent of banknote engraving.

One of the leading exponents of ex libris art during the late nineteenth century was Massachusetts-born Edwin Davis ("E.D.") French (1851-1906). His designs were tight and complex with dense elements—multiple scenes, portraits, and allegorical subjects. By combining etching and engraving techniques, he created beautiful pictorial designs.

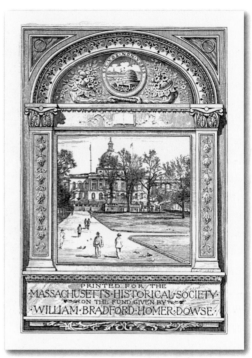

Sidney Lawton Smith bookplate

Sidney Lawton Smith (1845-1929) was also born in Massachusetts. He first worked as a steel engraver and expanded his knowledge of illustrating techniques through his work in publishing. The majority of Smith's two hundred etched or engraved bookplates exhibit his mastery of combining lettering with graphic elements.

Arthur Nelson Macdonald (1871-1940), another New Englander, experimented with wood engraving as a child and eventually took lessons in copper and silver engraving while working in a jewelry store. As an artist, he established a strong friendship and mentor relationship with Edwin Davis French. A distinguishing feature of his work is the use of frames surrounding graphic elements with lettering along the base of the frame.

Born in Watertown, Connecticut, William Fowler Hopson (1849-1935) was in his late teens when he started work as an engraver and moved to New York City. There he studied drawing and engraved book illustrations. Finally settling in New Haven, he continued illustrating books, including 2,500 blocks for an edition of *Webster's Unabridged Dictionary*. At age forty-three he created his first bookplate—for himself—eventually producing more than two hundred during his later career. Hopson's strength was in expressing the owner's individuality through images of homes, library interiors, and hobbies—generally set within an attractive frame.

Joseph Winfred Spenceley (1865-1908) was yet another Little

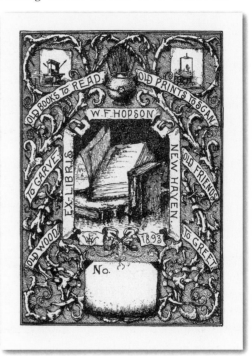

William Fowler Hopson's bookplate

Master born in Massachusetts. After studies in lettering and drawing, he worked as an engraver in Boston and Chicago. His 213 bookplate designs demonstrate his expertise in rendering landscapes.

THE FLOWERING OF ART NOUVEAU AND ART DECO BOOKPLATE DESIGNS

Ex libris designs increasingly became a reflection of the aesthetic, intellectual, and spiritual personalities of their owners. Frequently,

Walter Crane bookplate

too, the designs reflected political and economic crises of the times, as well as social changes, technical evolution, fashion, and the arts. From 1880 through 1940 the book arts and ex-libris designers adapted elements from art nouveau and art deco decorative styles. Characterized by expressive, asymmetrical decorative ornamentation, the art nouveau movement originated in London during the 1880s in reaction to the prevailing taste for history and tradition. Among the leading artists working in this style were Aubrey Beardsley, Kate Greenaway, and Walter Crane, all of whom were in much demand as bookplate designers. Typically, their bookplates included intricate, naturalistic floral borders and looping linear patterns reminiscent of intertwined plant tendrils.

Art deco, like jazz—its counterpart in the performing arts—sprang from the mood of the times. Bold designs, exuberant colors, and a preference for simple geometric forms were thought to be expressive of the machine age, then being embraced by a public eager for the new, the modern.

Kate Greenaway bookplate

❧ Bookplate Artists of the Twentieth Century

During the first half of the twentieth century, many of the best known artists, graphic designers, photographers, and architects tried their hand in designing bookplates. The list includes German Expressionist Oskar Kokoschka, British artists Edmund Dulac and Frank Brangwyn, and the Russian-born painter and printmaker Marc Chagall. In America many book illustrators and fine artists designed bookplates;

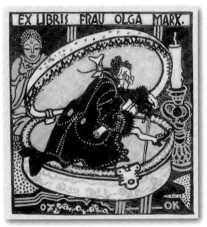

Oskar Kokoschka bookplate

among the most familiar names are Rockwell Kent, Howard Pyle, and Maxfield Parrish. Louis Agassiz Fuertes, a prolific painter of birds, incorporated a symbol of his profession—a hawk—in his bookplate. Leonard Baskin created a number of striking bookplates in the same expressive style he used in his sculptures, prints, and illustrations for children's books.

During the last thirty years or so, there has been a revival of interest in the book arts. A growing number of artists have been commissioned to create bookplates to benefit nonprofit organizations that collect or promote handcrafted books—such as the New York Public Library and Printed Matter Inc., a nonprofit organization specializing in artists'

Leonard Baskin bookplate

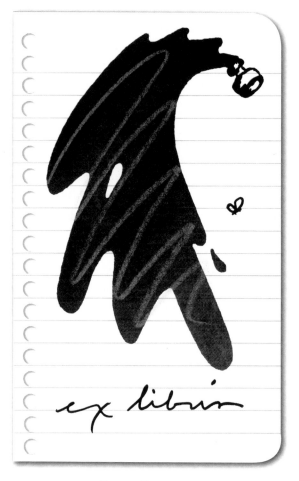

CLAES OLDENBURG
American (1929-)

One of the early proponents of the Pop art movement, Oldenburg explores the ironic and humorous aspects of everyday objects, often distorting them in size, shape, and materials. Although best known for his large-scale soft sculptures and giant outdoor installations, he also keeps a small spiral notebook to record ideas for future projects. This ex libris, with its delightful image of a bottle of ink spilling into the air, was printed on small sheets of paper with die-cut holes to simulate a sketchbook page. Fresh and witty, it is Oldenburg in miniature—proof of his uncanny ability to capture the essence of an object in just a few strokes.

books. Among contemporary artists contributing bookplates for projects such as these are Claes Oldenburg, Sol LeWitt, Robert Mangold, Elizabeth Murray, Faith Ringgold, Jenny Holzer, Vija Celmins, Robert Gober, Nancy Spero, and Eric Fischl. Their bookplates, like their original art, are personal and emotional expressions.

≈ A Brief History of Bookplate Collecting

During the late nineteenth century, bookplates were often produced in limited editions for their owners. Common printing techniques included copperplate and steel-plate engravings, wood engravings, etchings, mezzotints, and lithographs. Many of these original "prints" were designed by some of the best-known artists of the time. Signed and numbered by the artist, they were eagerly sought after by an increasing number of collectors. As bookplate design evolved into a recognizable art form, serious bibliophiles, historians, and collectors of graphic arts began their own collections.

In 1891 a small number of bookplate collectors met in London to establish the Ex-Libris Society. By the end of the year there were three hundred members in England, Europe, and the United States. Since then local and national associations have spread to most parts of the world. Idiosyncratic to this art form, most bookplate collections are built through the exchange of duplicate pieces. In order to have a ready supply of duplicates, collectors frequently have different designs made specifically for the purpose of trading with others. Collectors will commission dozens and perhaps hundreds of the finest, most important artists of the time while striving to increase the size, scope, and quality of their holdings. Some collections number in the hundreds of thousands.

In the United States the first bookplate society was founded in the nation's capital in 1896 as the Washington Ex-Libris Society. A year later the group changed its name to the American Bookplate Society. This association offered its members several different

publications and present-
ed exhibitions annually
through 1925.

Bookplate collecting
around the world has
ebbed and waned, reach-
ing its peak during the late
nineteenth and early twen-
tieth centuries and declin-
ing during World War I,
when communications
between artists and collec-
tors became increasingly
problematic. Shortly after
the war, however, new
bookplate societies were
founded, and renewed
interest in collecting pro-
liferated during the 1920s

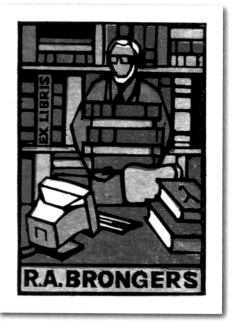

Henk Blokhuis bookplate

and '30s. Bookplates produced during this time reflect the decade's
innovations in the fields of graphic design and typography, as well as
decorative elements inspired by new modernist design.

During World War II, interest in designing and collecting book-
plates languished, but it gathered momentum once again during the
1950s. Today fine contemporary works are being produced by artists,
printmakers, and book illustrators throughout the world. Leading
printmakers in China and Japan are responsible for many beautiful,
multicolor woodcut ex libris. Many of these designs are rooted in tra-
ditional motifs, from simple, poetic landscapes to complex composi-
tions with flat areas of color and bold, rich patterning. Highly skilled
designers in Eastern Europe and Russia are producing bookplates
using exquisite mezzotint and aquatint techniques. Wood engravings,
copper engravings, serigraphs, and etchings are popular among
European bookplate designers, while in Canada, the United States,

Mexico, and South America, bookplates are produced in a wide variety of media.

Ex libris enthusiasts have established societies in nearly fifty nations with more than ten thousand artists and collectors participating. Every two years an international congress is held in a different country. Members of the world bookplate associations attend to exchange information, share resources, and commission new bookplates.

COLLECTING BOOKPLATES TODAY

In the past bookplate collectors often pasted their plates directly into scrapbooks; today's collectors tend to place them in clear archival sleeves for safekeeping. This makes it easier for collectors to trade among themselves. A typical collection resembles a veritable treasure trove of images that tell stories about their owner, the artists, and the tastes of the times. They also represent an intimate collaboration between artist and commissioner. As well-known contemporary Belgian collector and author, Luc Van den Briele wrote:

"An ex libris *should be a synthesis of the ideas and feeling of both artist and client. The commitment of the artist must be notably present, but the subject chosen by the commissioner must leave its mark on the result. The assignment is the heart, the artistic expression is the blood that makes the heart beat. The one cannot exist without the other."*

James P. Keenan
American Society of
Bookplate Collectors & Designers
Cambridge, Massachusetts

A Treasury of Bookplates

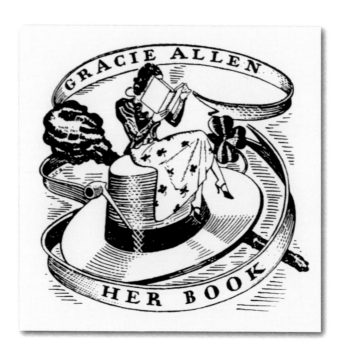

Gracie Allen
American (1902-1964)

Best known for her role as a television comedian in partnership with her husband, George Burns, Gracie Allen began her career in the early 1920s in vaudeville, film, and radio. Yet it was not until 1950 when The Burns and Allen Show *debuted on television that her popularity soared. The success of this early TV program depended largely on her zany character. Her bookplate shows Gracie in '50s-style dress, perched on top of a hat, book in hand. Typical of her quirky observations about life is a remark she once made on the air about reading books: "I read a book twice as fast as anybody else. First, I read the beginning, and then I read the ending, and then I start in the middle and read toward whatever end I like best."*

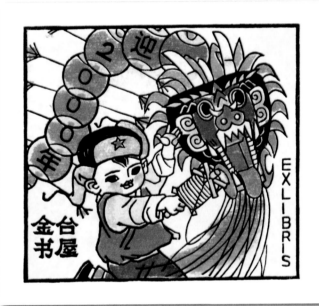

Yurii Bai
Chinese (Dates unknown)
An active member of a growing group of bookplate enthusiasts in China, Yurii Bai designed this personal ex libris in 2000 to celebrate the new millennium. Printed in seven colors, it is a delightful composition of a young Chinese boy with a colorful dragon kite. Scenes like this must have occurred during turn-of-the-century festivities in bustling cities and small villages all over China.

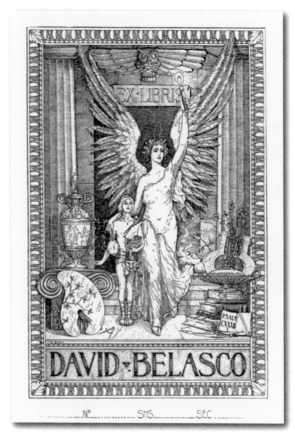

DAVID BELASCO
American (1853-1931)

Known for his innovative use of stage lighting, David Belasco was intimately involved in American theater from the age of nineteen, when he was manager of the Baldwin Theater in San Francisco. Belasco eventually moved to New York City, where, as a playwright, director, and producer, he became well known for his lavish sets. His bookplate is richly detailed and replete with symbolism relating to the theater, from the palette and lyre representing the creative arts to the mask of tragedy and various references to Greek theater. The winged allegorical figure holds aloft a light wand, no doubt denoting its owner's talent for dramatic lighting effects. The Belasco Theater (originally the Stuyvesant Theater), built by David Belasco in 1907, still stands today as a magnificent monument to its founder.

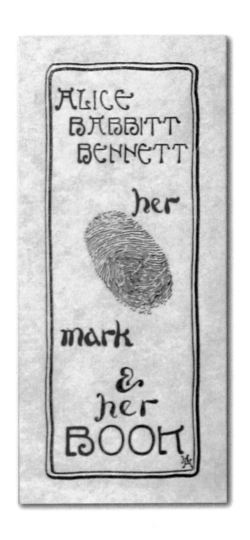

ALICE BABBITT BENNETT
(Nationality and dates unknown)
Although we have no information about Alice Babbitt Bennett, we have her mark—
a thumbprint—on her bookplate as evidence of her life. With this simple gesture, she reveals
an independent spirit and sense of humor that is rare in bookplate design.

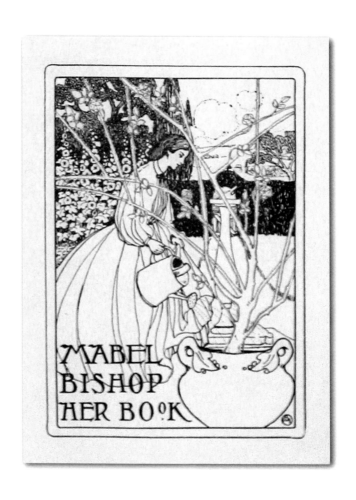

MABEL BISHOP
(Nationality and dates unknown)
*This charming domestic scene of a young woman tending her garden
gives insight into the life and pleasures of the bookplate's owner.*

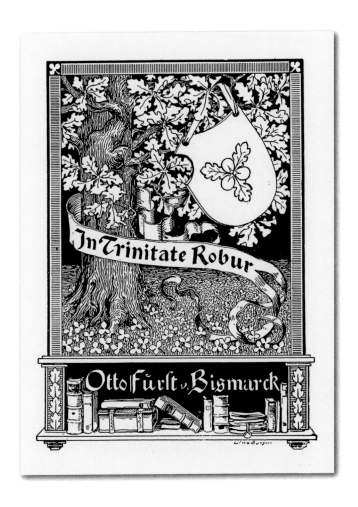

Otto von Bismarck
German (1815-1898)
Bismarck, a statesman known as the Iron Chancellor, instituted a program of sweeping social reform during the mid-1880s as he sought to arrest the advance of German socialism. His family's coat of arms included the shamrock and oak leaf featured in this bookplate designed by Lina Burger in 1895.

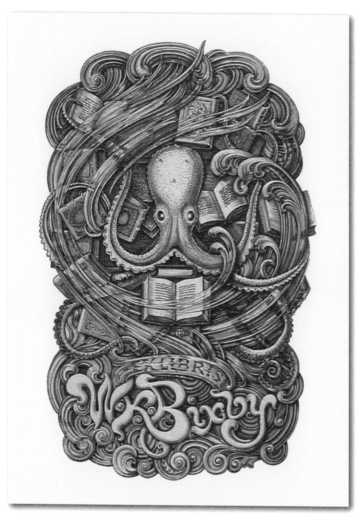

W. K. BIXBY
American (Dates unknown)

The outstanding copperplate engraver and popular bookplate designer Edwin Davis French (1851-1906) created this exuberant ex libris for W. K. Bixby. The octopus may be intended as a surrogate for Bixby himself. With its looping tentacles entwined around the many books swirling in its midst, the creature most likely represents a voracious reader. The virtuoso handling of sinuous line and rich detail is typical of French's engraving style.

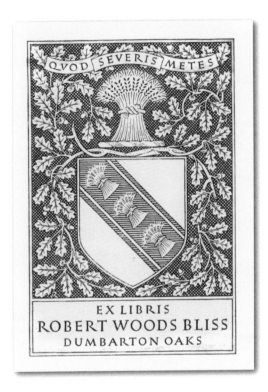

ROBERT WOODS BLISS
American (1875-1962)

The Latin motto "Quod severis metes"—"As you sow, so shall you reap"— on the bookplate of Robert Woods Bliss, founder of Dumbarton Oaks in Washington, D.C., is a fitting one. This Federal period home, with its magnificent gardens, was acquired by Bliss and his wife in 1920. They gave the estate to Harvard University along with a generous endowment that provided funding for maintaining the gardens, the house, and its contents, including the Bliss's valuable collection of rare books. The imagery on Bliss's bookplate—sheaves of wheat and oak leaves combined in an armorial design—is well suited to the vast and stately collection of books housed in the library of Dumbarton Oaks.

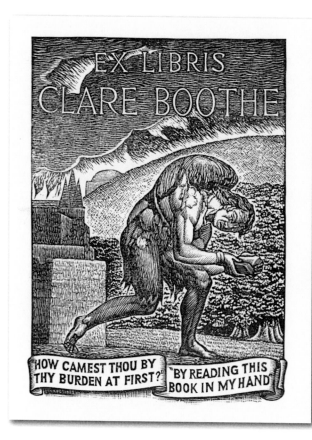

CLARE BOOTHE [LUCE]
American (1903-1987)

While this bookplate with its hunched-over figure in tattered clothes might seem out of character with Clare Boothe's vibrant personality, it nonetheless provides insights into her literary tastes and outlook on life. The image refers to a scene in John Bunyan's classic, Pilgrim's Progress *(1678). The burdensome book here is the Bible. Presumably this bookplate predates Boothe's second marriage, to newspaper publisher Henry Luce, and depicts a time in her life when she was in conflict over her own spiritual beliefs. She would later become a journalist for Luce's ever popular* Life *magazine, a congresswoman, and a diplomat. Ambitious, creative, and socially aware, she contributed much to society. Yet her bookplate reveals that in spite of her many successes, she related strongly to the spiritual seeker in the persona of this pilgrim.*

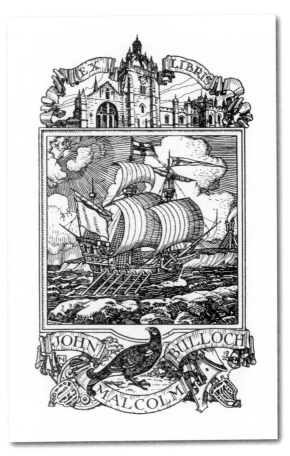

JOHN MALCOLM BULLOCH
British (1867-1938)

Journalist, critic, author, and genealogist, John Malcolm Bulloch was a native of Aberdeen, Scotland. His ex libris, designed by British artist Harold Nelson in 1928, includes imagery that refers to his personal and professional interests. Fascinated by the history and architecture of his native city, Bulloch wrote many books and articles about Aberdeen. The magnificent stone structure at the top of the plate is immediately recognizable to all who know the city. The sailing vessel—a slave ship, judging by the multiple sets of oars below decks—is being buffeted by a strong wind as it makes its way to the Caribbean. This represents Bulloch's extensive research into the history and genealogy of Aberdeen's Gordon family and their involvement in the slave trade. The relationship between the famous author and the designer of his ex libris was meaningful to them both, for Bulloch wrote the foreword to Nelson's book, Bookplates by Harold Nelson *(1929).*

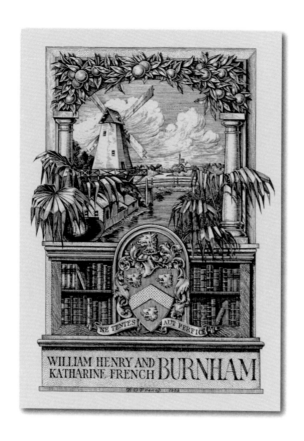

WILLIAM HENRY AND KATHARINE FRENCH BURNHAM
American (Dates unknown)

Designed in 1902 by E. D. French (1851–1906), this unusual pictorial bookplate incorporates a family coat of arms with the Latin motto "Do not attempt—Achieve." A puzzling but pleasant scene includes disparate elements, as if conjured from images in dreams. An arcade of lush tropical fruit surmounting classical columns serves as a framing device for the picture; a windmill along a tranquil canal draws our eye toward a distant vista; and a bookcase of handsomely bound volumes dominates the foreground. Rather than specific places in the real world, perhaps these images represent the places that we can travel to in our minds—transported into distant worlds through books.

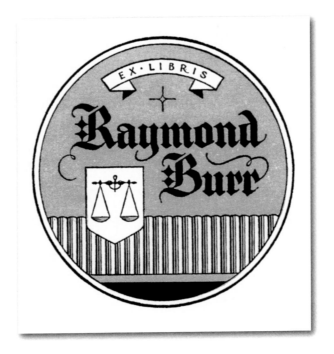

Raymond Burr
American (1917-1993)

The scales of justice are appropriate symbols for Raymond Burr's bookplate, created by Chicago-based artist, Carl S. Junge, who is best known for the elegant art deco book illustrations, bookplates, and posters he created during the 1920s and '30s. His design was inspired by the character played by Raymond Burr in the television series, Perry Mason (1957-1965). Burr played a brilliant lawyer whose courtroom tactics always bested his hapless opponents. This handsome bookplate aptly captures the indomitable spirit of the much-loved character Burr played so well.

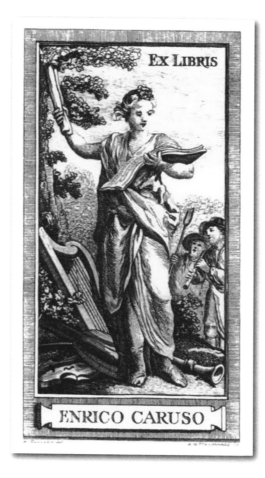

ENRICO CARUSO
Italian (1873-1921)

This allegorical bookplate for the talented Italian tenor from Naples depicts an animated female muse, libretto in hand. Set against a romantic landscape backdrop, with musical instruments at her feet, she takes center stage. The intense red color of the inked plate adds further drama to the scene. As much admired for his exuberant personality as for his rich and well-rounded voice, Caruso rose to international fame in the opera circuit from his debut in 1894 to his final performance in La Juive just a year before his premature death at age forty-eight.

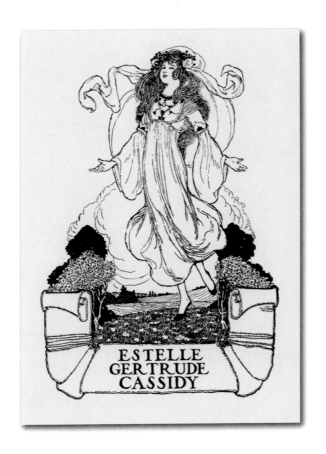

ESTELLE GERTRUDE CASSIDY
(Nationality and dates unknown)
This art nouveau-inspired image of a young maiden—her sheer, flowing gown blowing in the breeze as she strolls in a pastoral setting—offers few clues about the plate's owner or the artist who created it. Yet we can be assured that it belonged to someone young at heart, an inspiration to the artist who has so deftly captured her lively spirit.

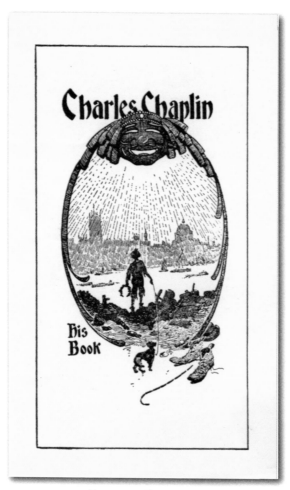

CHARLES CHAPLIN
American (1889-1977)

The unforgettable film star Charlie Chaplin appears in his bookplate as a child. Chaplin's trademark costume as the lovable Little Tramp was inspired by his early years, which were spent in a London workhouse and school for orphans. Gazing at the city's distinctive skyline across the Thames, the young boy seems poised between his past and the future. In the foreground, beneath an oval wreath crowned by the mask of comedy, are his signature shoes and cane. The muse Thespis, shining her rays of light upon him from above, is not only a symbol of his trade but also suggests the spirit of hope and optimism that granted him fame.

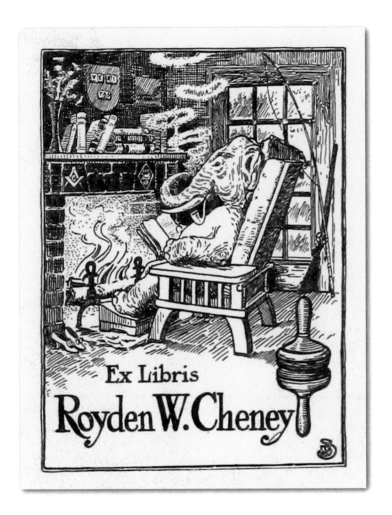

ROYDEN W. CHENEY
(Nationality and dates unknown)

The comforts of a warm fire, a good book, and a favorite pipe evidently captured the personality of this proud bookplate owner. The presence of a hunting rifle and spinning top indicate his other interests. This was a gentleman, sportsman, and book lover with a wonderful sense of humor.

Children's Bookplates

Some of the most charming bookplates—those designed for children—were especially popular from the 1880s to the early 1900s. Among the best-known artists and illustrators of this time were British artist Kate Greenaway (1846-1901), and American artist Rockwell Kent (1882-1971), both of whom designed a number of book-plates for children. Others, less well known, were no less appreciated. Illustrations on bookplates were rendered in a variety of mediums ranging from photographic representations to etchings, engravings, lithographs, and wood-block prints.

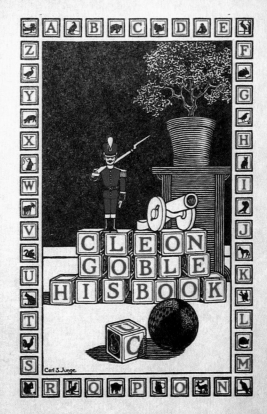

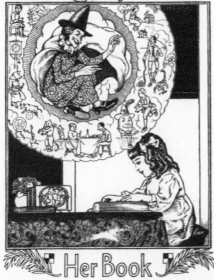

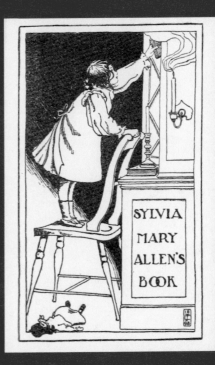

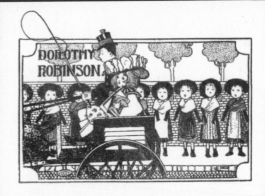

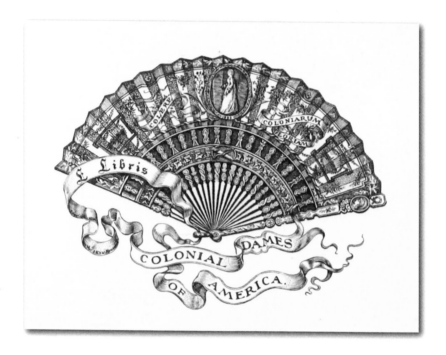

COLONIAL DAMES OF AMERICA

*This handsome fan-shaped ex libris designed in 1893 by E. D. French
(1851-1906) for the Colonial Dames of America is typical of his richly detailed
style of engraving that was so popular among clubs and societies during the late
19th century. Founded in 1891, the Colonial Dames of America supports historical
restorations around the United States for educational purposes and offers
scholarships to students of American history. Their Latin motto, which translates:
"To cherish the glory of the colonies," is an eloquent statement of their mission.*

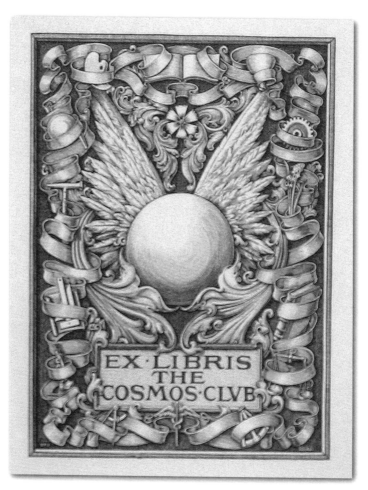

The Cosmos Club

Founded in 1878, the prestigious Cosmos Club in Washington, D.C., is a meeting place for top intellectuals in the sciences and arts. It was conceived as a cross-disciplinary social community, where people from different fields could meet one another. In the words of historian and club member Waldo Leland, the "solutions of difficult problems have resulted from the meetings of men in fields so far apart that only chance would have brought them together, who, in discussion of their problems, suddenly found the answer to questions that had baffled them." A pearl—the symbol of unblemished perfection—sits right in the middle of this bookplate, mirroring the high hopes that the founders had for their members.

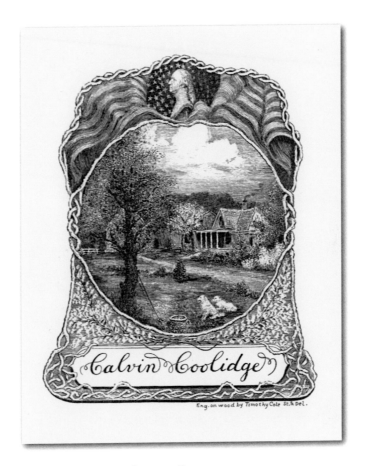

Eng. on wood by Timothy Cole Sc. & Del.

CALVIN COOLIDGE
American (1872-1933)

Timothy Cole (1852-1931) designed this fine bookplate for Calvin Coolidge, thirtieth president of the United States. The son of a village storekeeper, Coolidge was born in Plymouth, Vermont, in the farmhouse shown on this bookplate. He spent his formative years on the farm, helping with chores and enjoying the surrounding hills, woodland streams, and bucolic pastures. A fishing pole and basket indicate a favorite pastime. Following a long career in public service, as local councilman, governor of Massachusetts, and later as president, Coolidge returned to his boyhood homestead. It remained in the family until his widow, Florence, donated it to the state of Vermont in 1956.

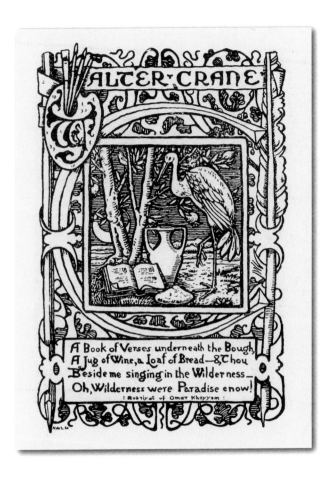

WALTER CRANE
British (1845-1915)

Best known for his charming illustrations for children's books, Walter Crane was a major force in the Arts and Crafts movement in England and founder of the Arts and Crafts Exhibition Society (1888). His ex libris is a wonderful example of the intricate ornamentation that characterized the art form he was so instrumental in popularizing. The border, with its lyrical floral motifs and elegant flourishes, surrounds a night scene with a crane peering over an open book. The initial C frames the central vignette, and at the bottom is a fragment of a verse from the Rubáiyát of Omar Khayyám.

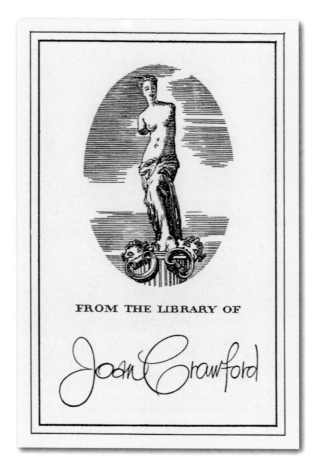

FROM THE LIBRARY OF

Joan Crawford

JOAN CRAWFORD
American (1908-1977)

Born Lucille Fay LeSueur in San Antonio, Texas, Joan Crawford worked her way up the ladder to stardom as a professional dancer and reached the chorus line of a Broadway revue. She was discovered by an MGM executive and made her movie debut in 1925. Her bravura performance in Mildred Pierce (1945) won her an Oscar as best actress. She was notorious throughout her illustrious career for her strong-willed, narcissistic personality, and her bookplate design reveals a flare for the dramatic. Here Crawford assumes the role of Venus de Milo, her face replacing that of the famous Greek statue, thus immortalizing herself as the modern embodiment of female beauty.

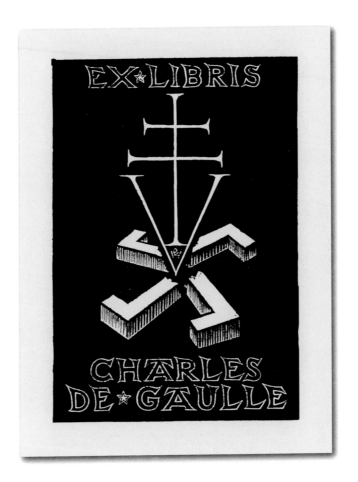

CHARLES DE GAULLE
French (1890-1970)

We can surmise that this ex libris, belonging to the imperious president of France, was designed after World War II. Here the cross of Lorraine, a distinctive two-tiered cross, is coupled with the Roman numeral V, standing for the Fifth Republic, of which de Gaulle was chief architect and later president from 1959 to 1969. During the war, the cross of Lorraine was recognized as a symbol of the Free French forces and of de Gaulle himself as leader of the resistance. In this striking, graphic bookplate, the cross of Lorraine and the Fifth Republic—both, of course, representing de Gaulle—have symbolically joined forces and crushed the despised symbol of Nazism.

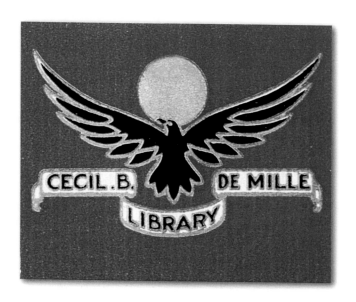

CECIL B. DEMILLE
American (1881-1959)

The legendary filmmaker was clearly drawn to eagle imagery. As a young man, he founded the Mercury Aviation Company, which used an eagle in its logo. Later in his life he was involved in a promotional campaign for his movie The Ten Commandments, *in which he partnered with the Fraternal Order of Eagles to display granite monuments of the commandments in public places, such as schools and municipal buildings.*

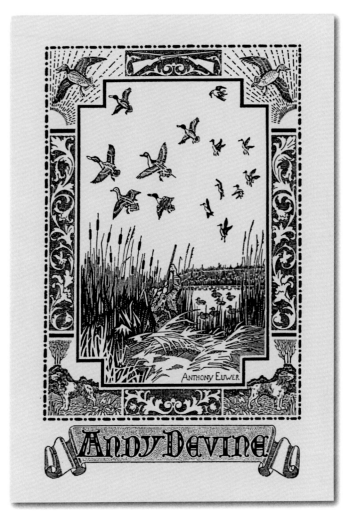

ANDY DEVINE
American (1905-1977)

Beloved raspy-voiced comedic actor Andy Devine was best known as a regular on Jack Benny's radio program and the television classic, Wild Bill Hickock. Here we see a private side of the entertainer, who must have been a hunting enthusiast, as his bookplate presents us with all the elements of an afternoon dedicated to the sport.

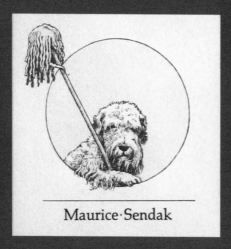

Maurice·Sendak

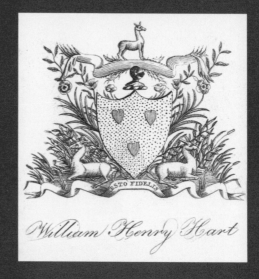

William Henry Hart

Animal Bookplates

Animals appear on a great many
bookplates. Some relate to the owner's
name, as in the case of Frederick Bull
and William Henry Hart. For others,
bookplates provided an opportunity to
proclaim their personal or professional
interests. John Hopkinson Baker, editor
of the popular book, *The Audubon Guide to
Attracting Birds*, commissioned a bookplate
with a pair of ducks taking flight. The
bookplate of Silvanus Macy, Jr., reveals
his love of fox hunting. The lovely pair
of closely entwined peacocks on Kate
Pembury's art nouveau-inspired bookplate
may be symbolic of a happy marriage.
Animal lovers also honored domestic
animals in their bookplate designs. Oscar-
winning film star Bette Davis (1908-1989)
included her pert little Scottish terrier,
Meg; Maurice Sendak (born 1928), the
renowned children's book illustrator and writer, designed
his bookplate to include the impish-looking dog from his
much-loved story, *Higglety, Pigglety Pop: Or, There Must be
More to Life*. Jennie, the moplike character in this book,
was modeled after one of Sendak's own pets.

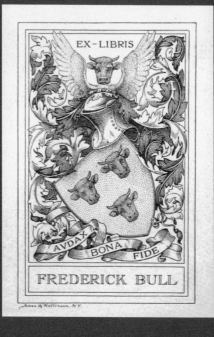

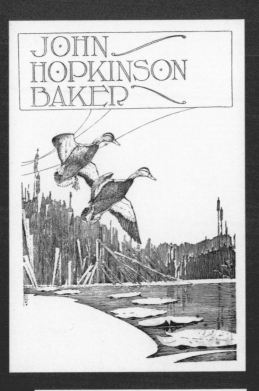

JOHN HOPKINSON BAKER

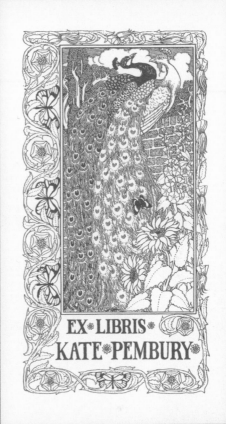

EX LIBRIS KATE PEMBURY

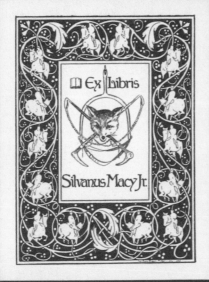

Ex Libris
Silvanus Macy Jr.

EX LIBRIS
BETTE DAVIS

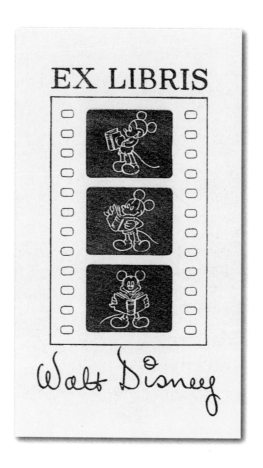

WALT DISNEY
American (1901-1966)

Walt Disney drew cartoons, directed live-action shows, and built a theme park, but he is most assuredly best known for his animated films and beloved cartoon characters. Disney's most famous creation, Mickey Mouse, is depicted here in a series of simulated film stills, showing the frame-by-frame process used to bring Mickey to life.

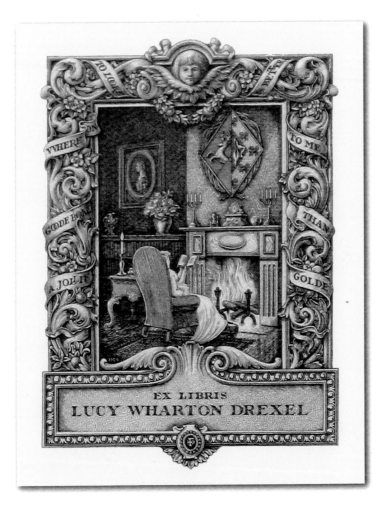

Lucy Wharton Drexel
American (Dates unknown)
Drexel inherited enormous wealth from her banking family and lived, no doubt, in splendid
luxury. Her reputation as a voracious reader was well known, and perhaps the quote framing the
opulent scene on her ex libris summed it up best for her. It is an excerpt from a short poem about
the love of books: O for a Booke and a shadie nooke, / Eyther in-a-door or out, / With
the greene leaves whisp'ring overhede, / Or the Streete cryes all about, / Where I
may Reade all at ease, / Both of the Newe and Olde, / For a jollie goode Booke,
whereon to looke, / Is better to me than Golde.

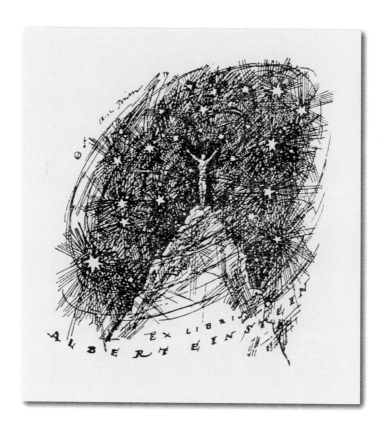

ALBERT EINSTEIN
American. Born in Germany (1879-1955)

Throughout his life and despite his numerous successes, one puzzle Einstein set out to resolve eluded him. Until his death he pursued a unified field theory—a way to explain gravity, electromagnetism, and subatomic phenomena in one set of laws—yet he was never able to accomplish this. In his ex libris we see a figure on top of a mountain peak with the entire cosmos swirling around him—an allusion, perhaps, to the vast complexity of theories about the universe with which he constantly grappled.

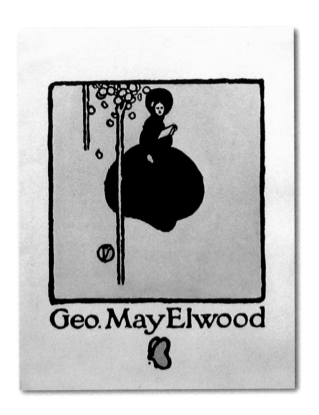

GEO. MAY ELWOOD
(Nationality and dates unknown)
Presumably made for a young woman of aristocratic means who was able to enjoy a good deal of leisure time, this ex libris probably dates from the early twentieth century. Based on the flat forms, simple composition, and delicate balance of positive and negative space, the designer was most likely influenced by Japanese prints, which had become popular as collectibles at the turn of the century.

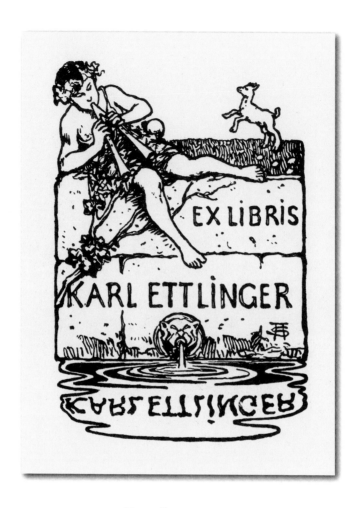

KARL ETTLINGER
German (1882-1935)

Born in Frankfurt, Ettlinger was a prolific writer. He contributed nearly two thousand articles to the Munich-based illustrated magazine, Jugend, which spawned a German arts-and-crafts style popularly known as Jugendstil. From its founding in 1896 through 1940, Jugend received contributions from many of Germany's most talented artists and writers. Frequent themes included art and poetry. Mythological characters such as Pan, whose familiar figure can be seen on Ettlinger's ex libris, were abundantly represented throughout the periodical.

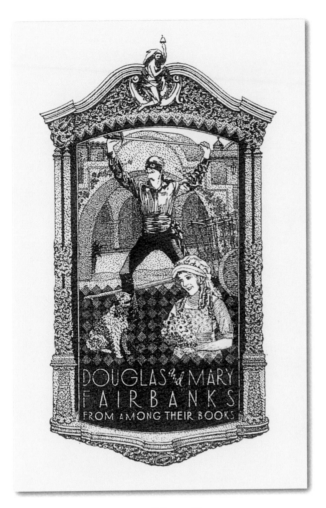

DOUGLAS AND MARY FAIRBANKS
American.
Douglas Fairbanks (1883-1939) Mary Pickford Fairbanks (1893-1979)
*Pioneers of Hollywood's silent movie era, this couple enjoyed the lavish lifestyle so often
identified with stardom. Elegant and dashing, Fairbanks resembled the swashbuckling
heroes he portrayed. His role as the masked hero in The Mark of Zorro is immortalized in
this bookplate, which also depicts Mary Pickford in a scene from one of her early films.
During their decade-long marriage, they reigned as Hollywood's royal couple.*

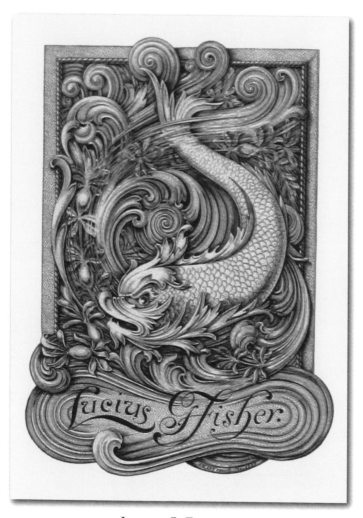

Lucius G. Fisher
American (Dates unknown)

Designed by E. D. French (1851-1906), whose richly detailed linear style of engraving made him extremely popular as a bookplate designer, this ex libris seems appropriate for a man whose surname is Fisher. The large, menacing-looking fish resembling imaginary sea monsters and the face of the wind blowing up a fierce gale in the upper left corner are reminiscent of early maps of the New World. The sinewy curves of waves and wind patterns create a lyrical, rhythmic, and well-balanced composition.

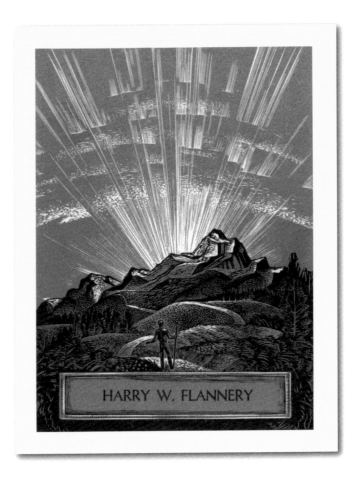

HARRY W. FLANNERY
American (1900-1975)

A newspaper and radio reporter, Flannery served as Berlin correspondent for CBS during World War II. Following the war, he settled in California, becoming a news analyst for CBS on the West Coast. The idealized pictorial style of his bookplate is reminiscent of late 1930s-early 1940s book illustration and bookplate design popular with West Coast artists.

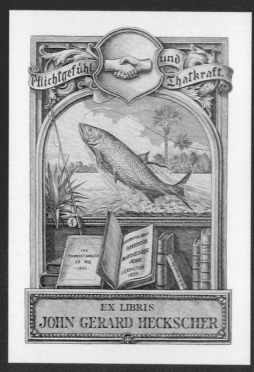

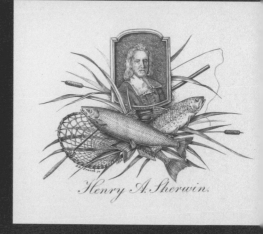

Angler Bookplates

Fishing scenes were extremely popular in pictorial bookplate designs from the early to mid-twentieth century. Ranging from tranquil depictions of anglers on lakes and rivers to fishermen wrestling with wild, thrashing, ocean-dwelling beasts, the scenes represented the preferences of each fisherman. Some anglers used images to represent their pastimes, such as the crossed fish nestled among cattails in Henry A. Sherwin's bookplate. Louis Rhead (1857-1926), a well-known children's book illustrator, evidently preferred the quiet pleasures of a woodland stream. For his bookplate, C. K. Lush, presumably a writer, chose a feather pen that doubles as a fishing rod. And the bookplate of John Gerard Heckscher (born 1837) highlights his extensive collection of books on the sport.

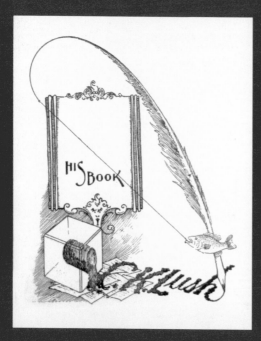

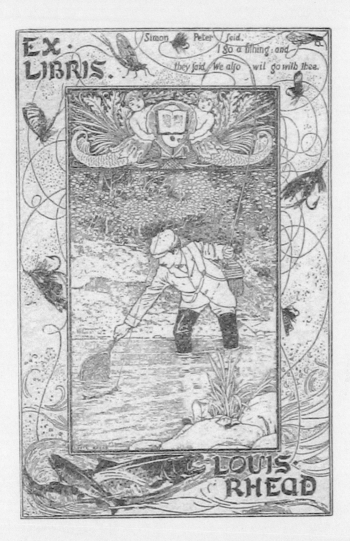

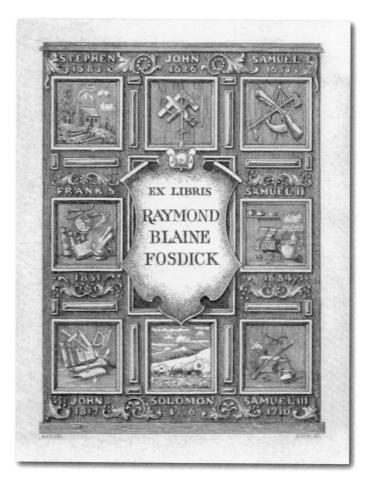

Raymond Blaine Fosdick
American (1883–1972)

Fosdick served in a number of prestigious positions, including commissioner of accounts for New York City and president of the Rockefeller Foundation. His bookplate is a celebration of several of his notable male ancestors, each represented by his first name, date of birth, and an image that captures the essence of his life. For example, Frank S.—short for Frank Sheldon—is represented by several of the tools of his trade as a schoolteacher and principal. Together all of the vignettes tell the story of the ex libris owner's genealogy.

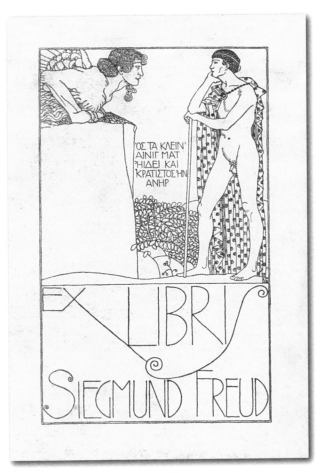

SIGMUND FREUD
Austrian (1856-1939)

This prominent Viennese medical doctor and psychologist is universally recognized as the father of psychoanalysis. One of the cornerstones of his theories is the Oedipus complex, named after the Greek god who unwittingly killed his father and married his mother. In Freud's ex libris, Oedipus confronts the monstrous Sphinx that terrorized travelers on the road to Thebes. According to the myth, the Sphinx posed its famous riddle, which Oedipus successfully answered, thus defeating the Sphinx and becoming the King of Thebes. This scene, with explanatory text in Greek, is rendered in the decorative art nouveau style popular during the late nineteenth century. It is quintessential Freudian theory made visible in a miniature work of art.

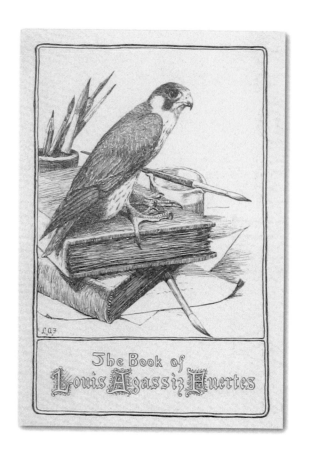

LOUIS AGASSIZ FUERTES
American (1874-1927)
*Fuertes developed a deep interest in painting birds and wildlife while still in his teens.
Turning his hobby into his profession, he became a successful watercolorist and was
compared in his time to Audubon. His insistence on painting from live subjects raised
the standard for wildlife painting in the twentieth century. Fuertes's bookplate
incorporates one of his own sketches and reflects his expertise and artistry.*

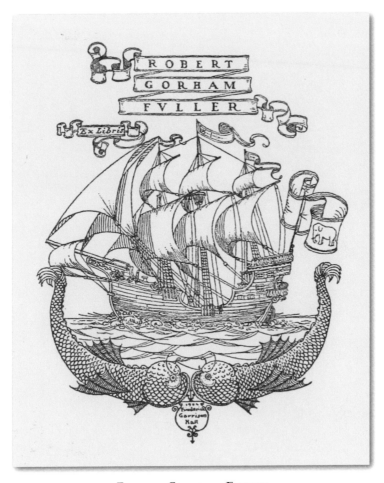

Robert Gorham Fuller
(Nationality and dates unknown)

Frederick Garrison Hall (1879-1946), one of America's most sought after printmakers, designed this distinctive bookplate. His graphic compositions were compact and well balanced. Nautical bookplates were extremely popular among ex libris lovers during the 1920s, when Hall was at the peak of his career. The act of sailing to a different world offers a wonderful metaphor for the act of reading. While not much is known about the identity of Robert Gorham Fuller, we can surmise that he greatly enjoyed escaping the day-to-day world with a good book.

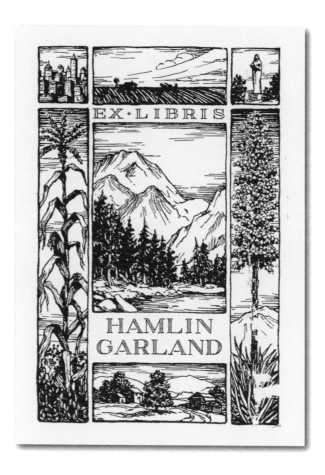

Hamlin Garland
American (1860-1940)

Garland was a writer who traveled extensively in the West, studying and writing about the Gold Rush, the American Indian, and the pioneer farm in a series of books that exemplified American realism. He later moved to New York City in order to be closer to the publishing world and to work on his memoirs. His bookplate features both the city and the landscape of the West, reflecting his lifelong passions.

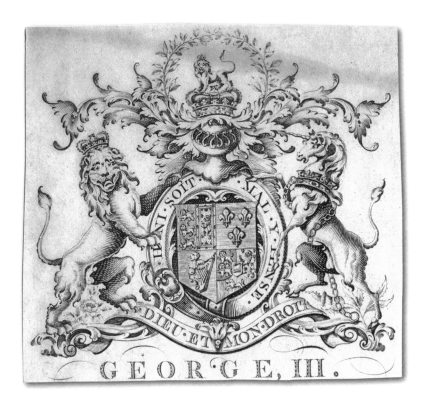

GEORGE III
British (1738-1820)

The royal coat of arms presented on George III's bookplate is rich with symbols of the United Kingdom and the monarchy. The lion, denoting England, and the unicorn, denoting Scotland, flank a shield that is ringed by the motto from an ancient order of knighthood: "Evil to him who evil thinks." Above is the royal crown, and below is the motto of the sovereign: "God and my right."

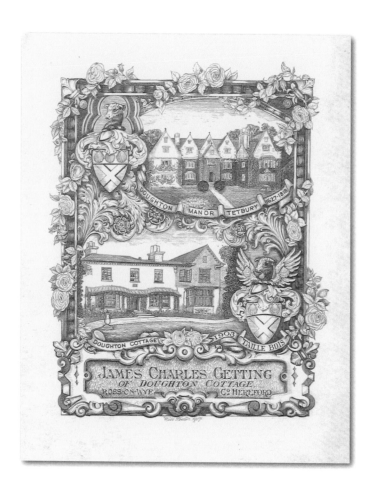

JAMES CHARLES GETTING
English (Dates unknown)

Charming vignettes of a manor house and cottage reveal the lifestyle of an English country gentleman during the time of Queen Victoria. Getting's bookplate incorporates both a formal coat of arms as well as garlands of roses looped gracefully over the outer frame.

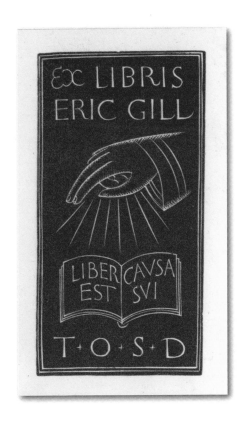

ERIC GILL
British (1882-1940)
*A sculptor, graphic artist, and type designer, Gill is best
known for the book designs he created in the 1930s. His
devotion to books and to type is evident in his bookplate.*

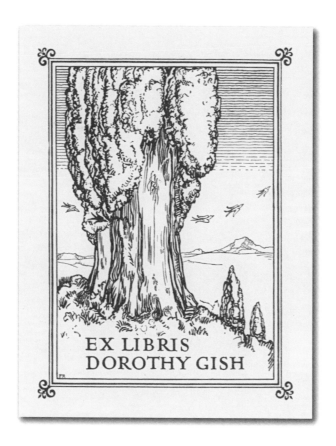

EX LIBRIS
DOROTHY GISH

Dorothy Gish
American (1898-1968)

Dorothy and her sister Lillian began acting on the stage at a very young age in order to help support their fatherless family. While Dorothy went on to have a respected film and theater career, she longed to be taken seriously as an actress; yet she was constantly cast in comedic roles and overshadowed by her more famous sister. Here we see an old, majestic tree rendered in great detail, perhaps intended to capture the timelessness that Gish yearned for in her performances and career.

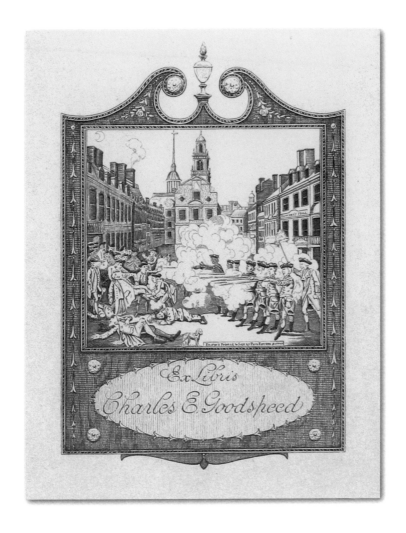

CHARLES E. GOODSPEED
American (1867-1950)
Noted historian, writer, and antiquarian bookseller, Goodspeed was the proprietor of Goodspeed's Book Shop, a well-known establishment in Boston. Inset in the ornamental framing device is the famous print of the Boston Massacre of 1770 by Paul Revere.

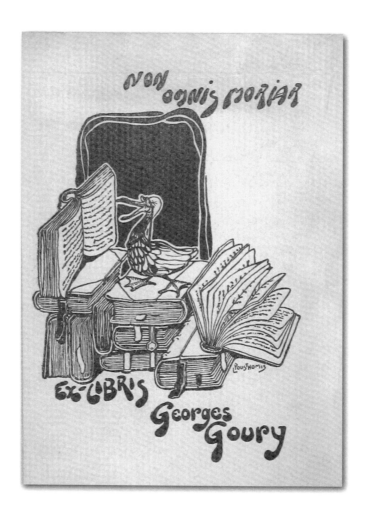

GEORGES GOURY
French (Dates unknown)

Although we have no specific information about Georges Goury, his witty bookplate design reveals a sense of humor. Yet the Latin inscription, "Not all of me shall die," shows his serious side. He may have been a writer with dreams of immortality through the printed word, or simply a proud book collector, pleased to leave his extensive library for others to enjoy.

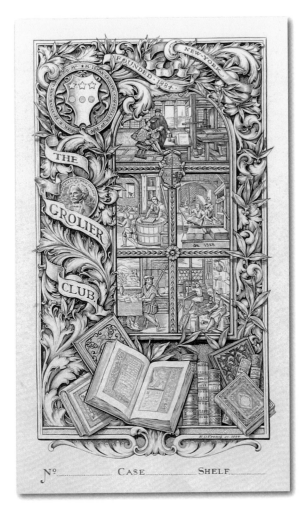

Nº _____ CASE _____ SHELF _____

The Grolier Club

The Grolier Club was founded in New York City in 1884. An organization of bibliophiles, it was named after Jean Grolier, the sixteenth-century French bibliophile and numismatist. E. D. French (1851–1906) designed and engraved this bookplate for the club in 1894. It incorporates Jean Grolier's coat of arms with illustrations of bookmaking, from papermaking to printing and bookbinding. In the curved top section is a remarkably detailed miniature rendering of the painting Grolier in the House of Aldus, *which hangs in the club's lobby today. Other images include an open book of hours at the lower edge as well as numerous books published by the Grolier Club.*

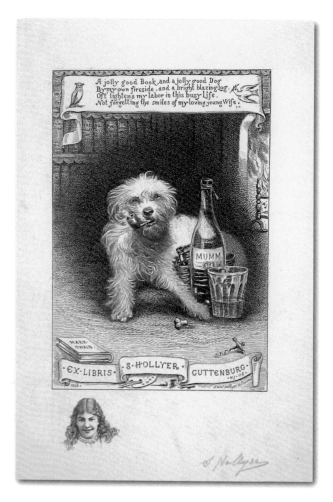

R. Hollyer Guttenburg
American (Dates unknown)

The charming little dog on the ex libris that Guttenburg designed for himself is probably intended to be a portrait of his own dog, who offers him one of the "comforts" referred to in the verse written on the banner above the animal's head. We presume that Guttenburg is a pipe smoker with a preference for fine champagne. His wife makes an appearance in the small vignette below; her smiling face provides a touch of reality to the otherwise whimsical scene.

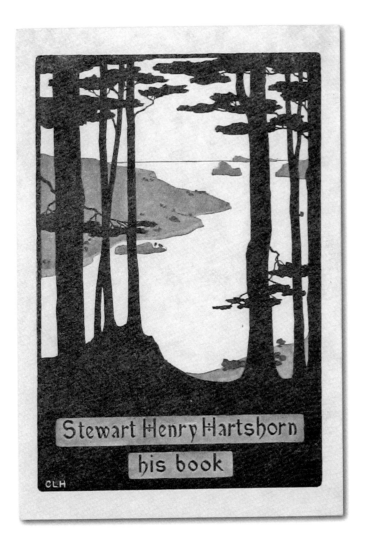

Stewart Henry Hartshorn

his book

CLH

STEWART HENRY HARTSHORN
American (Dates unknown)

With its flat, simplified forms and strong vertical composition, this bookplate design was inspired by Japanese wood-block prints that influenced many artists of the 1920s and '30s. Pine trees silhouetted against a rocky coastal scene provide a dramatic vista—a favorite, perhaps, of its owner.

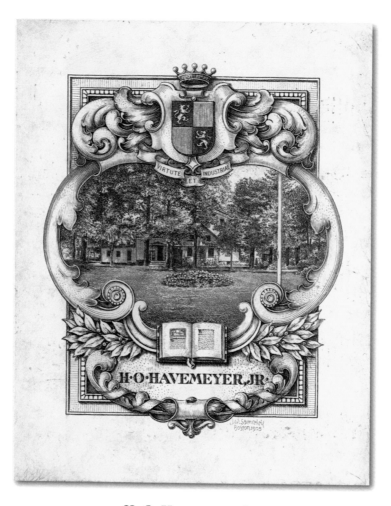

H. O. HAVEMEYER, JR.
American (Dates unknown)

This handsome bookplate combines the armorial and pictorial styles with the Havemeyer family crest surmounting a view of their country estate. The son of a prominent New York family, H. O. Havemeyer, Jr., enjoyed a life of privilege. His parents amassed a valuable art collection of old master and Impressionist paintings, which were donated to the Metropolitan Museum of Art in 1929.

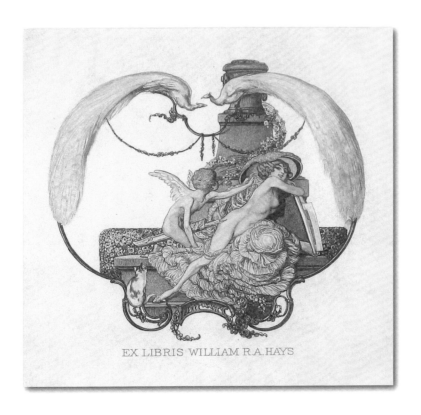

EX LIBRIS WILLIAM R.A.HAYS

WILLIAM R. A. HAYS
American (Dates unknown)

Vignettes such as the one on this bookplate provide visual clues to the interests and personalities of their owners. Peacocks with swirling tails, lush garlands of flowers, and a winged cupid speak of beauty, love, and innocence, while the lounging nude with marcelled hair and seductive smile alludes to the sensual side of life. This owner must be gentle and fun-loving, yet intelligent—a complex person fond of lively conversation.

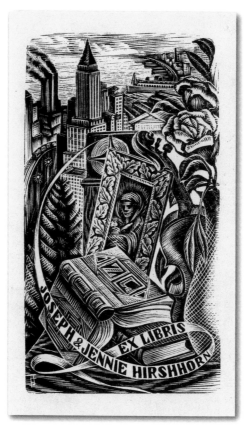

JOSEPH AND JENNIE HIRSHHORN
American. Married: 1922. Divorced: 1945.
Joseph Hirshhorn (1900-1981) Jennie Berman Hirshhorn (Dates unknown)

Born into poverty, Joseph Hirshhorn grew up in Brooklyn. To support his widowed mother and twelve siblings, he sold newspapers on Wall Street. He later made his fortune in the mining industry. This bookplate must have been commissioned during the early years of his marriage to his first wife, Jennie Berman. Vignettes of the city—its elegant skyline, the elevated subway snaking past Con Edison's smoldering smokestacks along the East River, and a tickertape looping around books—create a clever, if busy design. A fir tree, violin, and rose tell of other pursuits. The framed religious icon speaks of an interest in art, which later became a consuming passion for Joseph Hirshhorn. During his lifetime, he amassed a priceless collection of modern European and American art, which he donated to the Smithsonian Institution in Washington, D.C., where it is housed in the well-known museum bearing his name.

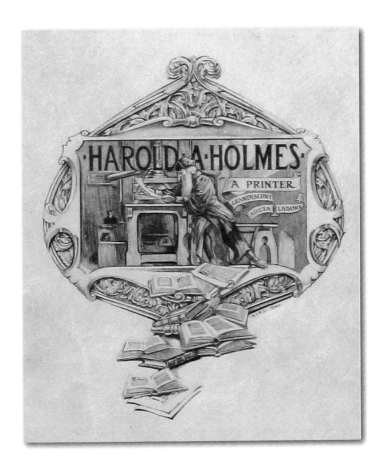

HAROLD A. HOLMES
American (Dates unknown)

In this bookplate designed by Elisha Brown Bird (1867-1943), the owner,
whose ex libris proudly announces his profession, is shown working on
a printing plate. Although his long white beard indicates advancing
age, Harold Holmes obviously believes in the work ethic, as revealed
in the very apt Latin motto: "By work, all things increase and grow."
As a printer, he may have been a colleague or friend of Bird's.

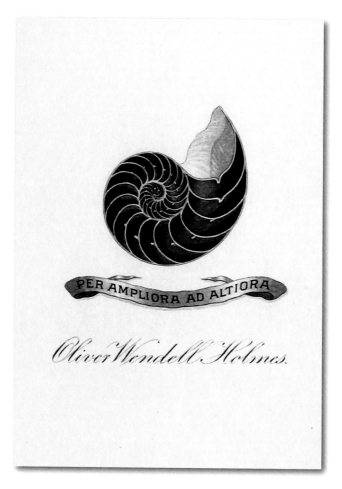

OLIVER WENDELL HOLMES
American (1809-1894)
A talented physician and poet, Dr. Holmes, father of the famous jurist, used the chambered nautilus on his bookplate. Long considered a symbol of lifelong and constant growth, the nautilus was the inspiration for one of Holmes's poems. The Latin inscription translates as "Through breadth to depth."

"The Chambered Nautilus"
Build thee more stately mansions, O my soul, / As the swift seasons roll!
Leave thy low-vaulted past! / Let each new temple, nobler than the last,
Shut thee from heaven with a dome more vast, / Till thou at length art free,
Leaving thine outgrown shell by life's unresting sea!

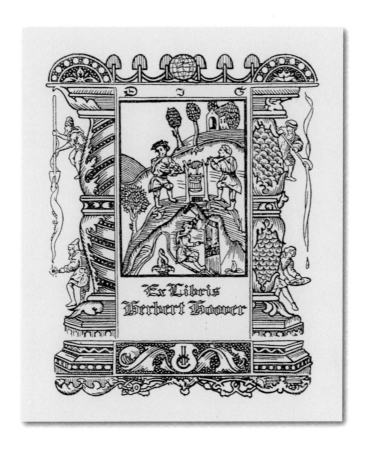

HERBERT HOOVER
American (1874-1964)

Although orphaned at the age of ten, Herbert Hoover became a millionaire through his mining interests and later, the thirty-first president of the United States. This bookplate, a Christmas gift from a friend, incorporates the title page of one of Hoover's favorite treatises on the history of mining and metallurgy. It shows a cutaway hill with a miner chipping away at the ore that is being lifted to the surface by workers above. Hoover was fascinated by the history of mining and became a passionate collector of rare books on the subject.

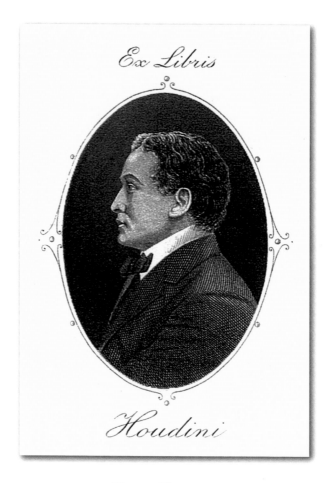

Ex Libris

Houdini

HARRY HOUDINI
American. Born in Hungary (1874-1926)

Born Ehrich Weiss, the legendary magician, escape artist, and showman began his professional life as a way to escape the drudgery of factory work that awaited many of his young immigrant contemporaries. Nearly eighty years later his name remains synonymous with magic and stagecraft. In this understated bookplate Houdini's instantly recognizable face is seen in profile, with the sedate image belying the drama and mystery that marked his career.

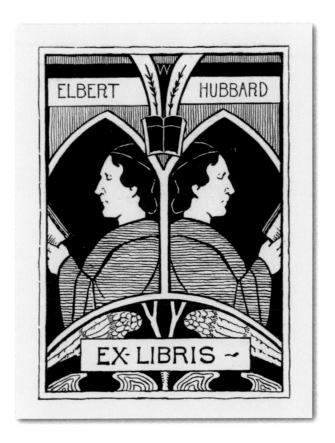

ELBERT HUBBARD
American (1856-1915)

Inspired by a visit to William Morris's famous Kelmscott Press in London, Hubbard founded the Roycroft Press in Aurora, New York, in 1895. The handsome Roycroft Press books with their fine leather bindings and elaborately decorated pages were eagerly sought after by collectors. The founder's ex libris, showing two back-to-back figures reading, is a completely symmetrical design rendered as a mirror image in a bold flat graphic style. An author in his own right, Hubbard also wrote and published the popular series, Little Journeys. Hubbard died on the Lusitania in 1915, but his company continued to be successful for many years afterward.

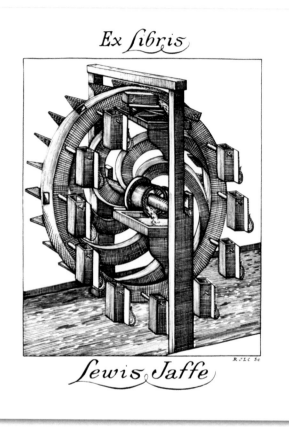

Ex libris

Lewis Jaffe

LEWIS JAFFE
American (1937–)

Bookplate collector and enthusiast Lewis Jaffe had this ex libris designed for him by British engraver Roy Cooney. It depicts, as the artist describes it, a "perpetual motion" device. But Jaffe does not attribute any great significance to the wheel, stating that it was based on a picture of an eighteenth-century waterwheel, which simply appealed to him aesthetically. Cooney's background as a mapmaker and his fine attention to detail make this a striking image.

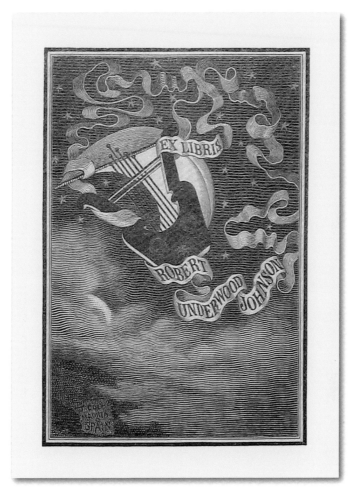

ROBERT UNDERWOOD JOHNSON
American (1853-1937)
Timothy Cole (1852-1931) designed this bookplate for Johnson, a fellow member of the American Academy of Arts and Letters. Johnson was a prominent personality in the academy, and Cole created several portraits of him during this time. Here, we see a lute—a symbol of the arts—transformed into a ship taking off for a journey through the sky.

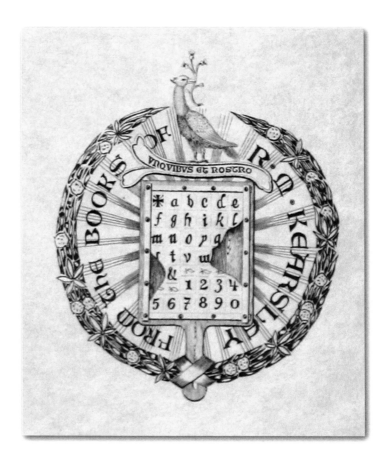

R. M. Kearsley
(Nationality and dates unknown)

*The exact interpretation of this bookplate is tricky at best. The slogan "Unguibus et rostro"—
"With claws and beak" — was adopted by U.S. Air Force fighters in World War II, leading us to
believe that the owner was somehow connected to that group. The hornbook motif might indicate
that Kearsley collected these early examples of "books"—actually wooden paddles covered with
thin sheets of cow horn—that served as teaching tools for children.*

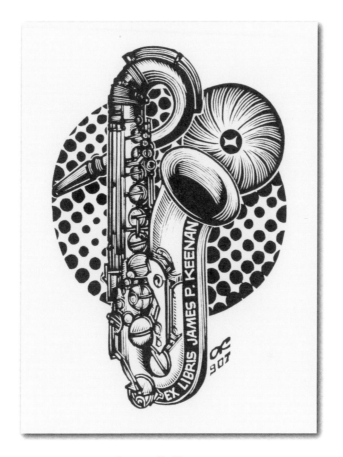

James P. Keenan
American (1951-)

Executive director of the American Society of Bookplate Collectors & Designers and the author of this book, James P. Keenan has commissioned a number of bookplates from his favorite designers. This handsome wood engraving by Russian-born artist Anatoli Kalashnikov, represents its owner's longtime passion for jazz. Keenan collects books about jazz and the artists who perform it, particularly from the 1950s and '60s. Bookplates relating to the Jazz Age are a popular subject for collectors, who frequently specialize in a particular genre and eagerly trade with other collectors.

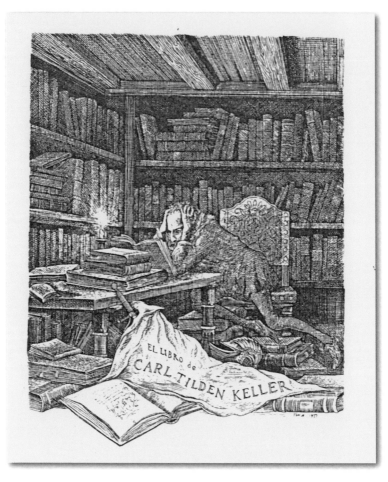

Carl Tilden Keller
American (1872-1955)

Slumped over a table, head in hand as if from exhaustion, this quintessential bibliophile reads by candlelight in a large library brimming with books. Does this amusing caricature represent the owner of the ex libris, intent perhaps on finding some piece of information that has long been alluding him? His attention is focused on one book while piles of other volumes—either already discarded or still awaiting his attention—are strewn all over the floor and on the tabletop. Has he finally found what he has been searching for? Or is he doomed to search forever?

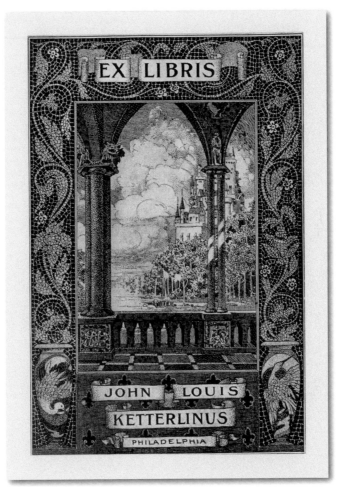

JOHN LOUIS KETTERLINUS
American (Dates unknown)

*This formal pictorial-style bookplate with its richly detailed mosaic border of
birds and vines was designed for a Philadelphia gentleman. Through an
arcaded balcony, a distant scene shows a turreted castle surrounded by trees.
Whether an imagined scene or the family's estate, one can only guess.*

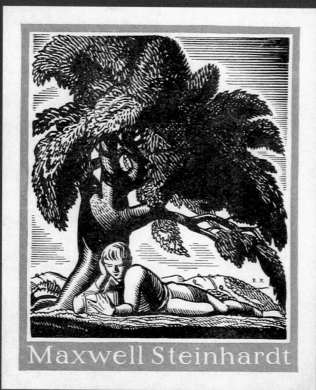

Maxwell Steinhardt

Rockwell Kent
American (1882-1971)

One of the most prolific and distinctive artistic talents of the twentieth century, Rockwell Kent designed more than 166 bookplates between 1912 and 1966. Kent approached each commission as a "personal matter" between artist and owner. His intimate relationships with many prominent members of American society—statesmen, politicians, philanthropists, writers, and celebrities—yielded singular designs for such well-known individuals as John Hay Whitney, Margaret Sanger, Joseph Kennedy, and Bennett Cerf. His bookplates always represented a distillation of the lives, tastes, and aspirations of his subjects. Rockwell Kent also made numerous contributions to the arts as a book illustrator, designer, and author. He illustrated many classics, including *Moby Dick, Candide, Beowulf, The Canterbury Tales,* and *The Complete Works of William Shakespeare.*

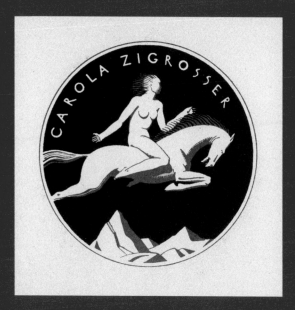

CAROLA ZIGROSSER
American (Dates unknown)
Rockwell Kent designed this elegant bookplate in 1933 for the fifteen-year-old daughter of Carol Zigrosser, a well-known art historian and longtime friend of the artist.

MARGARET SANGER
American (1879-1966)
A dynamic and controversial feminist, Margaret Sanger was a leader in the birth control movement and the founder of the Planned Parenthood Federation of America. In 1944, when Sanger donated her book collection to the New York Academy of Medicine, she asked her longtime friend, Rockwell Kent, to design a bookplate using a 1915 drawing he originally made for the cover of one of her birth control pamphlets.

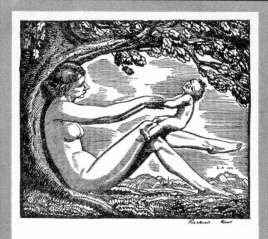

Margaret Sanger

EX LIBRIS

Rockwell Kent (continued)

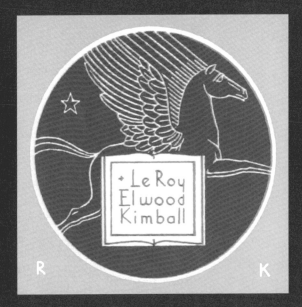

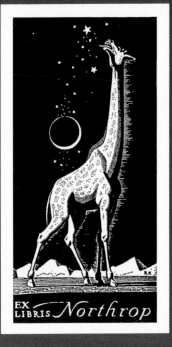

LeRoy Elwood Kimball
American (Dates unknown)

Pegasus, the winged horse of mythology, appears numerous times on Kent's bookplates. Stanley Marcus, head of the luxury retailer Neiman Marcus, initially rejected the Pegasus for his bookplate because it closely resembled the logo of Mobil. Kent later sold the design to LeRoy Kimball for one hundred dollars. Kent agreed to redesign Marcus's ex libris, yet he recycled the Pegasus several times after this, altering it only slightly from plate to plate. His clients, who frequently had to endure long waits for Kent to fill their orders, did not seem to mind that the imagery was not unique to their bookplate.

George Norton Northrop
American (Dates unknown)

A resident of Chicago, Northrop ordered an ex libris by Rockwell Kent in 1930, requesting "something about giraffes." He must have been delighted when he received this image of a stately giraffe reaching toward the stars. In a letter dated 1940 to The Century Association's archivist describing his bookplate, he stated, "We are a tall family but we do not disdain the north."

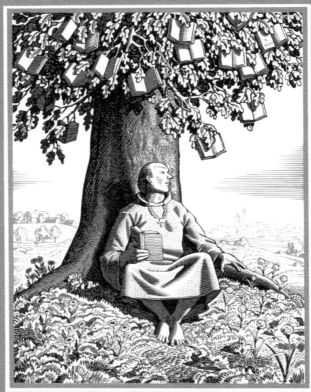

EX LIBRIS
JOHN WHiTiNG FRIEL
HELEN OtiLLiE FRIEL

JOHN WHITING FRIEL AND HELEN OTILLIE FRIEL
American (Dates unknown)

A World War I hero and steel industry executive, J. Whiting Friel commissioned Rockwell Kent to design this bookplate for the folio-size books in his extensive collection. Designed in 1953, it is Kent's largest bookplate. Filled with family references, it depicts a barefoot monk seated beneath a book-laden tree. The distant skyline on the right suggests Cincinnati, Mrs. Friel's native city, while the farmhouse on the left refers to the Friel homestead in Maryland. Carved in the tree are the words Queenstown and Jennkintown, where the Friels resided at the time the bookplate was made.

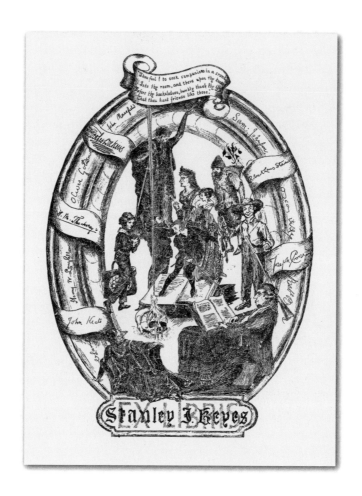

STANLEY KEYES
American (Dates unknown)

This pictorial bookplate features various figures, perhaps literary characters, framed by signatures of famous authors, among them Charles Lamb, John Keats, Henry Wadsworth Longfellow, William M. Thackeray, Oliver Goldsmith, Charles Dickens, and others. The motto above: "Thou fool! to seek companions in a crowd, into thy room, and there upon thy knees before thy bookshelves, humbly thank thy God that thou hast friends like these."

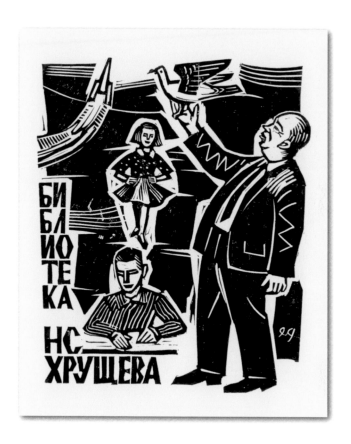

NIKITA KHRUSHCHEV
Russian (1894-1971)

*The son of a miner, Khrushchev rose through the ranks of the working class and the
Communist Party to become the world-famous leader of the Soviet Union. He broke
with Stalin's rigid interpretation of communism but replaced it with his own brash
style of political dictatorship. His ex libris, designed by E. Grabowski, depicts the
Soviet leader, dove of peace in hand, and a rocket ship blasting off into space—
representing the two extremes of power he wielded during the Cold War era.*

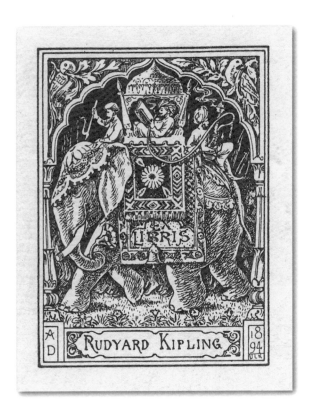

RUDYARD KIPLING
British (1865-1936)

Rudyard Kipling is best known for his collections of verse and romantic animal stories, including Kim, The Jungle Book, *and the* Just So Stories, *but his taste for adventure is evident in this bookplate designed in 1909 by his father, John Lockwood Kipling, an artist and teacher. The character pictured here, riding in an ornate carriage on the back of an elephant, is said to be the author himself.*

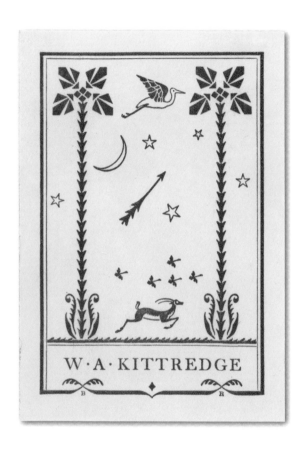

W. A. KITTREDGE
American (Dates unknown)
*This winsome bookplate was designed by Bruce Rogers (1870-1957), probably
in the 1940s. An innovative typographer and book designer, Rogers joined
the staff of Riverside Press of the Houghton-Mifflin Company and was a
consultant to the presses at Oxford University and Harvard.*

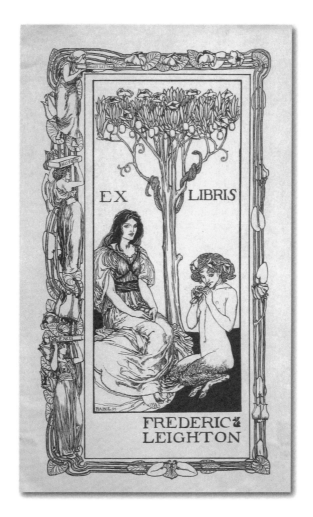

FREDERIC LEIGHTON
British (1830-1896)

*Leighton was a well-known artist of the Victorian classical school of painting.
This bookplate reflects his interest in classical subjects, antiquity, and
mythology, as evidenced in the cloven-hoofed figure of the Greek god Pan,
ruler of the woodlands, fields, nature, and fertility.*

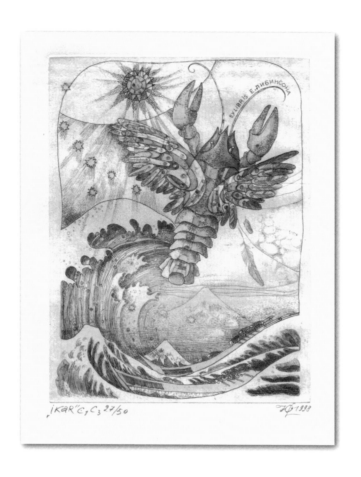

E. LIBINSON
Russian (Dates unknown)

Designed by Moscow-based artist Yurii Smirnov, this ex libris masterfully combines steel engraving and etching. It shows a surging sea with a winged lobster rising toward the sky. The familiar white-crested wave with Mount Fuji in the distance is copied from the famous print, The Great Wave Off Kanagawa, *by Japanese artist Hokusai (1760-1849).*

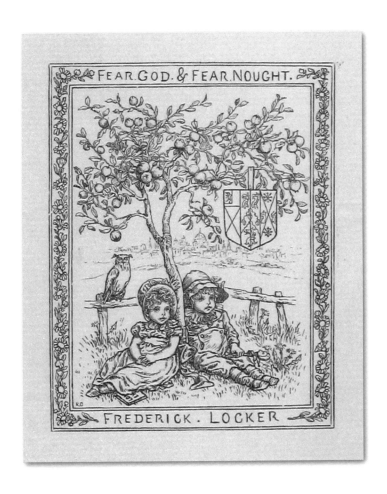

FEAR.GOD. & FEAR.NOUGHT.

FREDERICK . LOCKER

FREDERICK LOCKER
English (Dates unknown)
This charming bookplate was designed by Kate Greenaway
(1846-1901), one of England's most popular children's book
illustrators. It is typical of her delicate linear style.

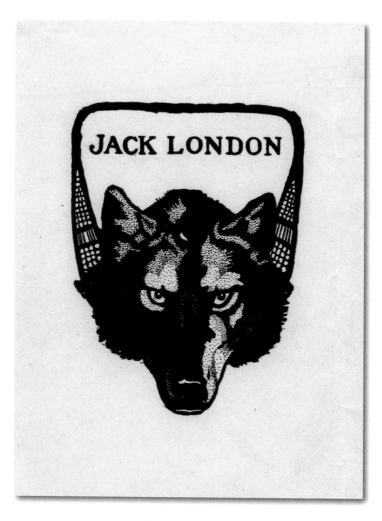

JACK LONDON
American (1876-1916)

Jack London's Klondike tales are exciting, vigorous, and brutal. The Call of the Wild (1903), his story about a tame dog who eventually leads a wolf pack, is one of the finest animal stories ever written, beloved by generations of readers. The book was no doubt the inspiration for his distinctive bookplate.

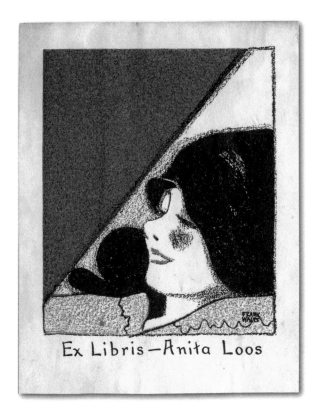

Ex Libris—Anita Loos

ANITA LOOS
American (1893-1981)
Actress, screenwriter, and novelist, Anita Loos is best known for her first novel,
Gentlemen Prefer Blondes, *which made its stage debut in New York in 1926. Although
the play about the life of Lorelei Lee, the archetypal dumb blonde, made Loos an instant
celebrity, the 1953 film version starring Marilyn Monroe was even more popular. In a
bookplate designed in bold outlines with brilliant touches of color, Loos is captured at the
height of her career, with her distinctive profile and flapper hat so typical of the 1920s.*

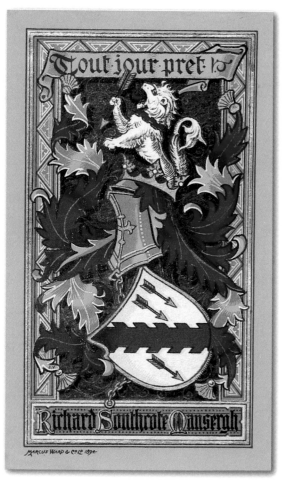

RICHARD SOUTHCOTE MANSERGH
British (Dates unknown)

This handsome ex libris is an example of the fine work of Marcus Ward & Co., a prominent printing and publishing concern with offices in Belfast and London. From the mid-1860s to the mid-1890s the firm was a leader in the industry, producing some of the most beautiful greeting cards, calendars, and advertising ephemera of the time, which were highly sought after by members of British society. Ward would have charged Mansergh a pretty penny for his colorful armorial bookplate, and it is likely that he also produced matching stationery for Mansergh, using the same coat of arms and motto: "Always prepared."

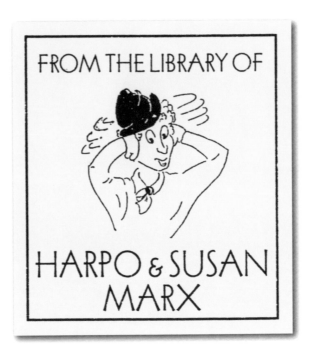

HARPO AND SUSAN MARX
American
Harpo Marx (1893-1964) Susan Marx (1909-2002)
Harpo and Susan Marx were both consummate entertainers—he, one of the famous Marx Brothers, and she, a Ziegfeld's Follies girl. When they were not performing, they enjoyed dabbling in painting and drawing. The childlike spirit of Harpo is captured in this delightful, quickly sketched portrait, which they used as their bookplate.

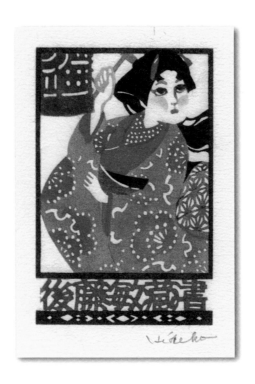

HIDEKO MATSUBARA
Japanese (Dates unknown)
Using the ancient Japanese dye stencil technique known as katazome, Hideko Matsubara has created many elegant, colorful images that recall traditional Japanese prints. Every print is unique in this painstaking, six-staged resist process, which produces glowing multicolor images. Her ex libris is typical of the kind of complex patterning that can be achieved by using this hand-stenciling process.

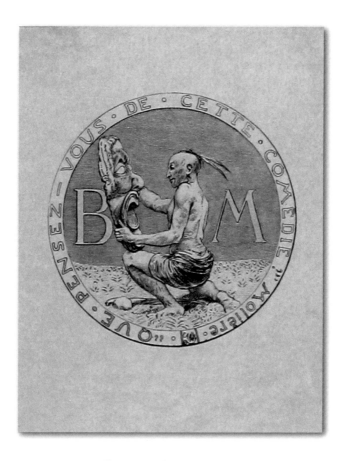

BRANDER MATTHEWS
American (1852-1929)

In this allegorical bookplate designed by the well-known illustrator and muralist Edwin Austin Abbey (1852-1911), a Native American is seen holding a mask representing Greek comedy as he ponders the concept of theater. Framing the scene are Molière's words that translate, "What do you think of this comedy?" For Brander Matthews, a collector of books about French drama and an author of several books relating to the French and American stage, this bookplate brought together all of his interests—both personal and professional. Among his many accomplishments, Matthews was the first professor of dramatic literature at any American university, teaching the subject at New York's Columbia University.

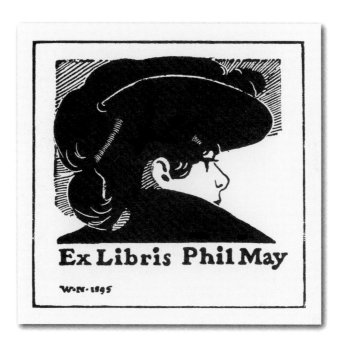

PHIL MAY
British (1864-1903)

This elegant figure, executed in broad flat areas of black and accentuated with crisp, bold, white linear strokes, recalls the lively cartoon sketches that Phil May created for London's popular magazine Punch *throughout the 1890s. Born into poverty and orphaned at the age of nine, May selected most of his subjects from among London's lower classes. His illustrations and caricatures of street urchins, cockneys, sportsmen, and performers brought London's teeming street life into every home. His ex libris was designed by British painter William Nicholson (1872-1949), best known for his illustrations for the popular children's book,* The Velveteen Rabbit *(1922).*

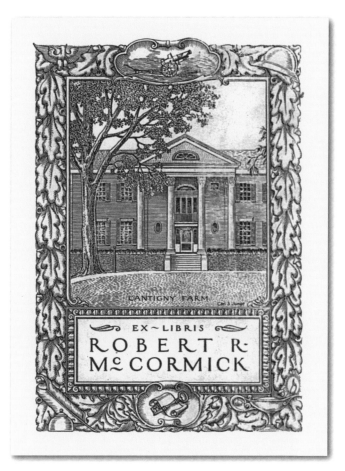

ROBERT R. MCCORMICK
American (1880-1955)

After serving as an officer in World War I, Colonel McCormick returned to his native Chicago to take over ownership of the Chicago Tribune from his brother. Conservative and isolationist in his own politics, he demanded that the Trib reflect his narrow attitudes, essentially filtering the news to suit his wishes. For pleasure McCormick sought the relative calm of his country home, Cantigny Farm, which forms the central image of his ex libris. Oak leaves—representing strength—form a decorative border around the plate. Corner motifs include a World War I howitzer and helmet. An author in his own right, McCormick wrote several books on American history. The quill pen and inkpot in the lower left are symbols of his trade.

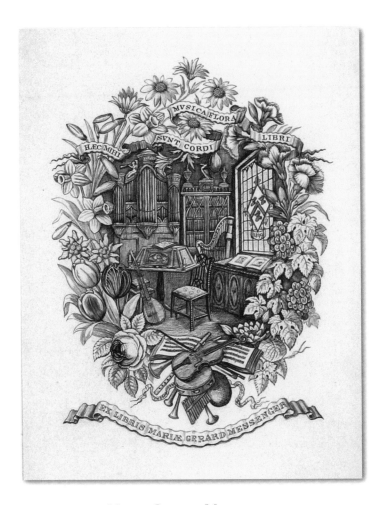

MARIE GERARD MESSENGER
(Nationality and dates unknown)

This bookplate most certainly belonged to a woman whose life was richly enhanced through music. A pipe organ dominates the left side of the central image, while other elements include a violin, a mandolin, various horns, and a tambourine. The Latin motto refers to music, flowers, and books—obviously her sources of pleasure. The charming vignette of the interior of her library is encircled by a wreath of fruit and flowers. A lyrical design, resplendent with ornamental detail, it is a beautiful example of the pictorial ex libris style, with a light, feminine touch.

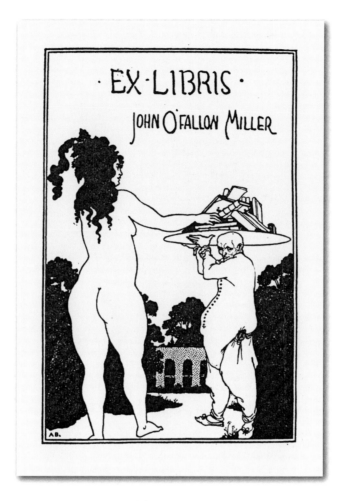

John O'Fallon Miller
(Nationality and dates unknown)
Designed by Aubrey Beardsley (1872-1898), this bookplate wittily reflects Beardsley's departure from the traditional gender boundaries so prevalent in Victorian society. Here a nude woman piles book after book on a platter supported by her diminutive male servant, who bows under the weight of his burden. Beardsley's "New Woman" is empowered and strong, free to pursue knowledge and liberated in her sexuality. Beardsley is best known for illustrating the works of Oscar Wilde.

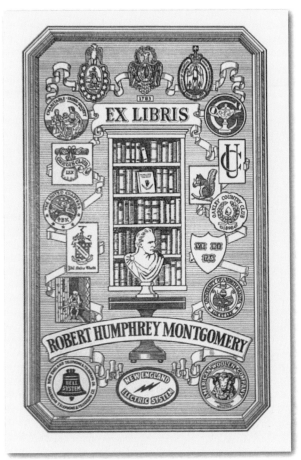

ROBERT HUMPHREY MONTGOMERY
American (Dates unknown)

From the magnificently detailed bookplate of Robert Humphrey Montgomery, we can surmise much about his life. Although a bookcase is the central motif, it is the surrounding roundels and crests that are the real focus of attention. The seal of the Charitable Irish Society reveals his ancestry and philanthropic nature. We see that he was a member of the Oakley Country Club (in Watertown, Massachusetts) and can thus assume that he lived nearby. Montgomery was an intelligent and accomplished man of many interests, and we have evidence of the college and university he attended as well as his membership in the Phi Beta Kappa Society. We may also assume that he worked for or was associated with New England Electric System, the Bell System, and the American Woolen Company. Bookplates such as this, which provide so many visual clues to the past, are treasured by family members and historians alike.

John Pierpont Morgan
American (1867-1943)

An elegant example of the armorial style, this gold-embossed leather bookplate incorporates the coat of arms of the Morgan family, including the head of a stag and a rampant dragon. John Pierpont Morgan became head of the venerable Morgan banking enterprise in New York when his father died. He inherited a Palladian-inspired building in Manhattan designed by McKim, Mead & White for his father's vast collection of rare books, paintings, and art objects. Morgan donated the handsome building and its contents to the public in 1924 and named it the Pierpont Morgan Library in memory of his father. This ex libris, originally commissioned by Morgan senior, was pasted into every book in the collection. Conservators at the library are removing them to prevent the leather from staining the facing pages.

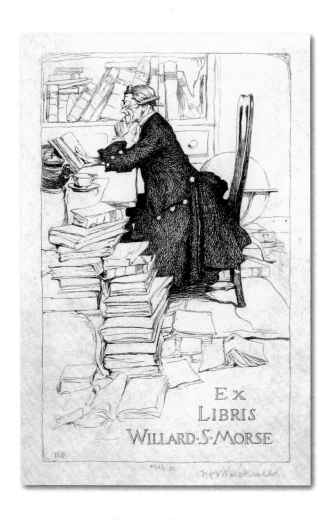

WILLARD S. MORSE
American (1856-1935)
Mining executive Willard Samuel Morse amassed a large collection of the work of the
illustrator Howard Pyle (1853-1911), who designed this plate. Morse was even inspired to
write two books about the artist. Here we see a whimsical portrait of the bookish Morse
reflecting, perhaps, on some interesting aspect of the life of the artist he so admired.

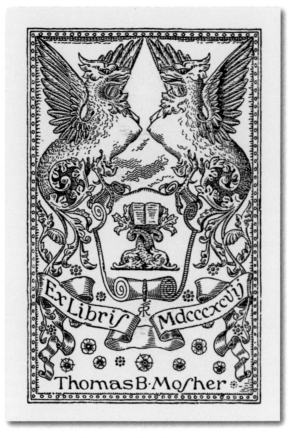

THOMAS B. MOSHER
American (1852-1923)

Born in Portland, Maine, Mosher was a noted book publisher and an important figure in the revival of fine printing in America during the late nineteenth century. His publications, which number more than seven hundred, reflect aspects of the Arts and Crafts, pre-Raphaelite, aesthetic, and art nouveau movements. Affectionately known as the "literary pirate" or the "Portland Pirate" because of his liberal interpretation of the copyright laws, Thomas pilfered many of his editions from popular English and European books. Yet he is credited with introducing Americans to many works of literature that would otherwise have gone unnoticed. His bookplate, designed in 1897 by Frank R. Rathbun, a local Maine artist, was for the books in his extensive library. A light, airy version of an armorial plate, it shows two double-breasted griffins facing each other and two dolphins holding a book.

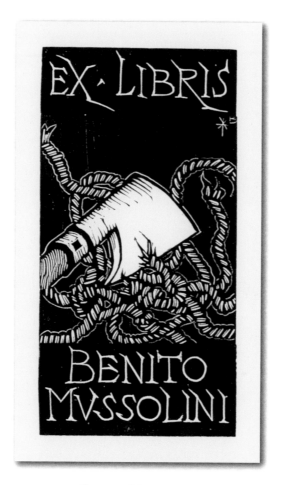

Benito Mussolini
Italian (1883-1945)

The Fascist Party in Italy was so named after the fasces, an ancient Roman tool made from rods, bound with rope, and offset with an axe, which is represented here. As with the swastika, an honorable symbol assumes a sinister meaning. Previous to Mussolini's rise, the fasces was reproduced on U.S. currency and can be seen to this day as a decorative element on the arms of Lincoln's chair at the Lincoln Memorial.

EDWARD J. NALLY
American (Dates unknown)

A pioneer in all forms of electrical communication during his long career in the wireless business, Nally served as vice president of American Marconi. In his bookplate, he incorporated a verse from Thoreau's often quoted poem, 'Inspiration.' He explains his use of the quote in a letter dated 1940 that was written to a colleague at New York's prestigious Century Association: "Thoreau in his poem, 'Inspiration,' probably 'never dreamt of it in his philosophy,' but I have liked, presumptuously, maybe, his thoughts in terms of prophesies and apply their meaning to the miracle of wireless."

Calvin Neff
American (Dates unknown)
Because there is no record indicating that Calvin Neff commissioned this ex libris directly from Rockwell Kent, we must assume that Neff simply adapted this illustration as his bookplate without the usual collaboration—or permission—of the artist. Kent's stark portrait of the obsessed Captain Ahab served as the frontispiece for the original Lakeside Press edition of Herman Melville's famous classic Moby Dick. *Published as a three-volume set with two hundred and eighty illustrations and packaged in an aluminum slipcase, the book sold for seventy dollars at the time and was extremely popular.*

The Name Game

Book collectors frequently revealed a sense of humor in designing and commissioning their bookplates, particularly if they could make a word-play game using their own names. One owner proudly announces, "I am A. Bookman," with a scene of a gentleman selecting a book from his library. A colorful pair of bookplates belonging to Jack and Elizabeth Diamond was designed as a deck of playing cards—the jack and queen of diamonds. A frolicking cow with the distinctive black and white markings of a Holstein pays homage to its owner, Mark Holstein, on a wood engraved bookplate designed by Allen Lewis (1873-1957). Richard Wynkoop, whose name we must assume is pronounced "wine," incorporated images relating to winemaking on a handsome armorial bookplate. Henri Seyrig's choice of an opossum with two babies clinging to its tail is a witty pun on his surname, which is derived from the French word, "sarigue,"

meaning opossum. An internationally known French numismatist and archaeologist, Seyrig (1895-1973) spent much of his career in Greece and the Middle East, collecting ancient coins and ceramics. His bookplate, with its stylized images resembling the black-figure decoration typical of Archaic Greek vase painting, is not only a pun on his name but is also a reflection of his interest in antiquity.

I am
A. Bookman

JACK DIAMOND

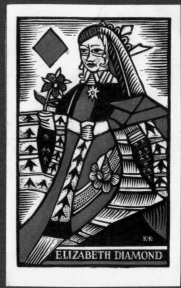

ELIZABETH DIAMOND

VIRTUTEM COLERE

HILARITATE

Richard Wynkoop

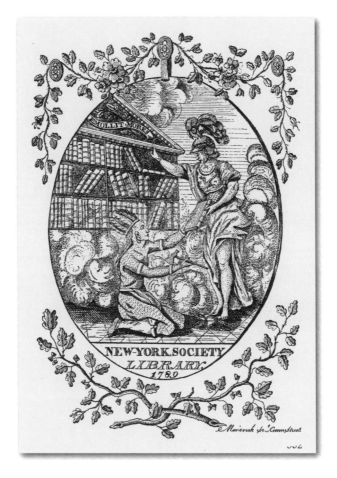

NEW YORK SOCIETY LIBRARY

Founded in 1754 by a civic-minded group committed to making books available to its subscribers, the New York Society Library is the oldest library in the city. The Latin motto, which roughly translates, "Learning humanizes character," is certainly in keeping with its mission. The ex libris, dated 1789, was designed by Peter Rushton Maverick (1755-1811), who was one of the most prolific engravers in Colonial America. In this allegorical bookplate, Minerva, the Roman goddess of wisdom, offers the benefits of education to a grateful Native American kneeling at her feet.

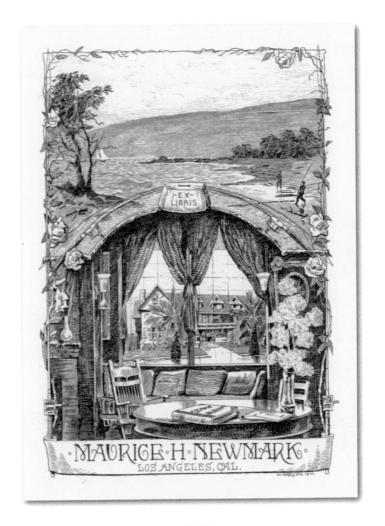

MAURICE H. NEWMARK
American (Born 1859)

Maurice H. Newmark was the editor of several volumes on the history of California. Presented here is an imaginary estate, nestled deep below the ground, and children fishing in a lake above. Perhaps, as much as he loved the California landscape, Newmark desired some safe refuge from the earthquakes he frequently wrote about.

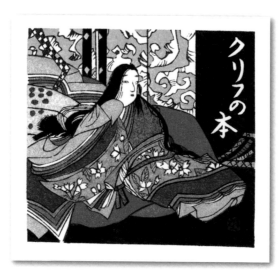

CLIFF PARFIT
Japanese (Dates unknown)

A well-known contemporary Japanese wood-block printmaker, Katsue Inoue is recognized as one of the classic bookplate artists working today. This ex libris presents an image of Lady Murasaki Shikibu, author of The Tale of Genji. *This eleventh-century book is considered the earliest novel in Japan and the first novel in the history of literature. Commissioned by Cliff Parfit, director of the English Centre in Shimonoseki City, Japan, the plate is printed from ten wood blocks and measures only 3-5/8 by 3-5/16 inches—a veritable masterpiece in miniature.*

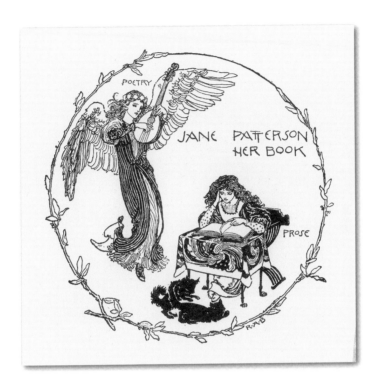

JANE PATTERSON
British (Dates unknown)

Designed by Robert Anning Bell (1863-1933), an important art nouveau painter, illustrator, and teacher, this bookplate shows a young girl reading while being serenaded by a winged muse playing a lyre. Two cats frolic at her feet. The linear quality is quite lyrical; the long, graceful curves of the draped muse making a striking angular diagonal through the quaint scene. A wreath of branches encircles the composition, leaving a good deal of open white space that lends an airy feeling to the overall design. Although Bell is best known as an illustrator, he designed a number of mosaics for London's public buildings, including Westminster Cathedral and the Houses of Parliament. It must have been a great honor for Jane Patterson to have her ex libris designed by this distinguished artist.

SAMUEL PEPYS
British (1633-1703)
Pepys is best known for his celebrated diary—an intimate record of the daily life and reflections of an ambitious, observing, and lusty young man. The diary extends from January 1, 1660, to May 31, 1669, offering a graphic picture of the social life and conditions in England during the period. The nautical motif used for this bookplate relates to Pepys's career in the British navy, where he began as a clerk in 1660 and rose to the position of secretary of the Admiralty in 1673.

GEORGE A. PERERA
American (Dates unknown)

Obviously a portrait of its owner, this humorous bookplate tells us much about the gentleman who commissioned it. His comical expression, large nose, and gaping mouth reveal a person who enjoys a good laugh. The crinkles around his eyes show he has found much pleasure in life. Though little of substance is revealed in this caricature, one can assume that Perera had a fine sense of humor about life and about himself.

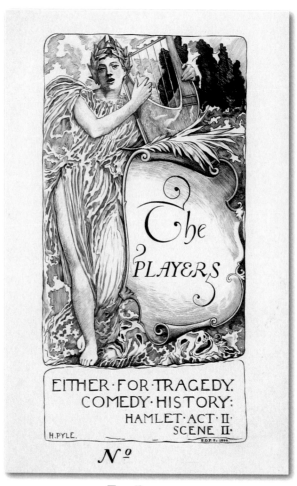

THE PLAYERS

Howard Pyle (1853-1911), one of America's foremost illustrators and an author in his own right,
designed this bookplate for The Players, a theater group in New York. Best known for his
dramatic and colorful illustrations for such popular children's books as The Story of King
Arthur and his Knights, Book of Pirates, *and* The Merry Adventures of Robin
Hood, *among others, Pyle was founder of the Brandywine School of painting, which*
influenced many artists during America's Golden Age of Illustration. His bold, graphic style
was much in demand for ex libris designs. Pyle's imagery includes a winged Apollo, patron of
music and theater, holding a lyre. Beneath his feet are the masks of comedy and tragedy.

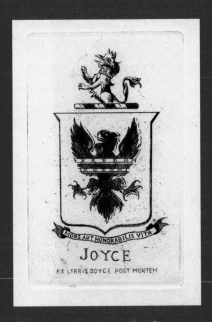

Posthumous Bookplates

Bookplates are often created after the death of a book collector. In most cases booksellers or other individuals involved in the estates of the deceased commission the designs. Books belonging to Robert Browning, Lewis Carroll, E. M. Forster, Mark Twain, and James Joyce, among others, were known to have been plated posthumously. On his death in 1941, James Joyce left a sizable collection of books and manuscripts, which were sold in Paris in 1949. The armorial bookplate shown here was designed by printmaker and book illustrator Johnny Friedlander, specifically for this sale. It was copied from a drawing of Joyce's coat of arms, which was one of the author's prized possessions. The Latin motto translates, "Death or life with honor."

The portly figure of writer and historian, Leonard L. Mackall (1879-1937), was immortalized in a posthumous bookplate created by John Held, Jr. (1889-1958), famous for his captivating cartoons of the Jazz Age for *The New Yorker, Life*, and other popular magazines. Mackall bequeathed his book collection to his favorite club, The Century Association, in New York. Another club member, Clarence Day, best known as the author of *Life with Father* (1935), created the charming drawing that was later used in an ex libris to identify books donated to the club in Day's memory.

WALTER CONWAY PRESCOTT
American (Dates unknown)
This handsome ex libris affords multiple views of the owner's home. The interior of his modest cabin is rendered in exquisite detail, while a sketchy vignette of its exterior and the surrounding landscape hint at a rustic, secluded setting. The modernist architectural framing motif and graphic rendering pay homage to the Arts and Crafts movement that evolved in England during the late nineteenth century. In America, Frank Lloyd Wright was one of its leading proponents. Wright's theories about the harmonious relationship between a house and its natural surroundings may have been on the mind of the artist as he designed this bookplate.

Princeton University Library

In this straightforward, rather stately bookplate designed by E. D. French (1851-1906), an image of Princeton's library is most prominent. The flowers and ornate border mimic the marble flourishes used as ornamental elements elsewhere on the campus. The official seal is to the left; the Latin text surrounding it translates, "Seal of Princeton University." On the shield an open Bible rests above a chevron, which symbolizes the rafters of a building, with the motto "Dei sub numine viget"— "Under God she flourishes"—surrounding it.

FRANK WOOD RICHARDSON
American (Dates unknown)

A young man sits reading a book. A shield with the three lions of England rests below the book, a compass adorns the bench beneath him. To the right is a stained glass window; to the left, an open view onto a pastoral setting. Such a setting probably refers to the serious nature of this gentleman. Does the compass imply an interest in architecture, or was he possibly a Freemason? What were likely easily discernible symbols to the artist and subject are somewhat mystifying to us today. We do know that Richardson was in the manufacturing business and that he was a resident of Auburn, New York. Because he was a member of the prestigious Century Association from 1904-1952, we also have some idea of his character and intellectual and social pursuits.

EX·LIBRIS·
ABBY·ALDRICH·ROCKEFELLER·
AND·JOHN·D·ROCKEFELLER·JR·

JOHN AND ABBY ROCKEFELLER
American
John D. Rockefeller, Jr. (1874-1960) Abby Aldrich Rockefeller (1874-1948)
*This scene offers a glimpse of the neoclassical country home Kykuit, the
Rockefeller family estate in Pocantico Hills, New York. Built at the initiative of
John D. Rockefeller, Jr., the sprawling mansion and grounds became a weekend
retreat for three generations of the family. In addition the family frequently
invited a variety of statesmen, intellectuals, and industry leaders to their home.
Kykuit is now a historic site of the National Trust for Historic Preservation.*

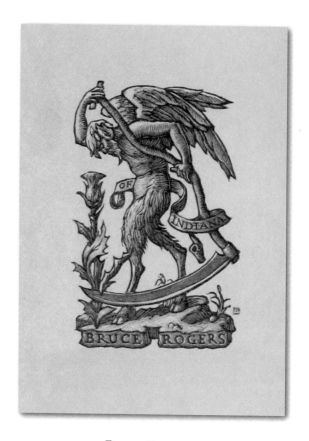

BRUCE ROGERS
American (1870-1957)

Rogers was born in Linwood, Indiana, and was one of the foremost book designers in America. His bookplate, adapted from a 1914 printer's mark in his collection, was engraved and printed by Allen Lewis (1873-1957) in 1939. Here, a bearded satyr with extended wings is seen in a simple composition. Half human, half goat, he is hunched over under the weight of a larger-than-life sickle. Usually associated with Bacchus, the Greek god of wine and pleasure, satyrs were historically portrayed as carefree sylvan spirits. Perhaps this rather grim impersonation of a satyr was intended as a comment on Rogers's attitude toward his chosen profession, for he once said, "The real pleasure of making a book is over when the plan is decided and the actual work begins. From that time on there is merely the drudgery of manufacturing it."

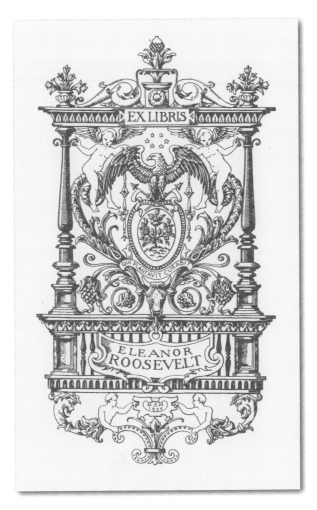

ELEANOR ROOSEVELT
American (1884-1962)

A dedicated humanitarian, author, and political figure, Eleanor Roosevelt was the niece of Theodore Roosevelt and wife of U.S. President Franklin Delano Roosevelt. An outspoken advocate of human rights, she served as a delegate to the United Nations and was a key figure in the creation of the groundbreaking Universal Declaration of Human Rights (1948). Her heraldic bookplate reflects her commitment to the country she served so well.

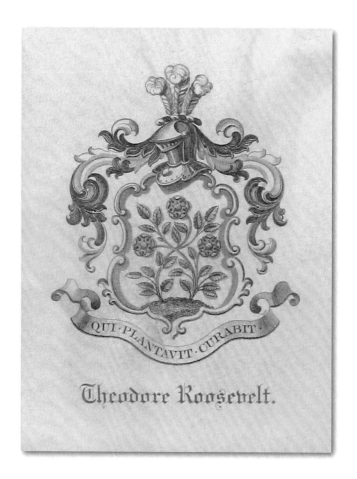

QUI · PLANTAVIT · CURABIT ·

Theodore Roosevelt.

Theodore Roosevelt
American (1858-1919)

This handsome bookplate features the coat of arms of the Roosevelt family and their motto, which translates, "He who has planted will preserve." The central image shows three rosebushes in full bloom. The crest is surmounted by a helmet topped with three ostrich feathers. Elegant and graceful, the bookplate served America's twenty-sixth President and his family well through many generations.

Royal Library at Windsor Castle

The vast holdings of rare books and manuscripts in the Royal Library represent centuries of collecting by members of the British royal family. The library's bookplate has undergone numerous transformations over time. In this version, which represents the triumph of good over evil, Saint George appears on horseback, spear in hand as he strikes the rearing dragon. The familiar motto, "Evil be to him who evil thinks," is from the Order of the Garter, founded by Edward III, circa 1344.

WILLIAM SAMPSON
American (Dates unknown)
Although the identity of William Sampson is unknown, we can be certain that he was involved in the theater. The clown is presumably Sampson himself, balancing a feather on his nose while dancing on top of a pile of masks.

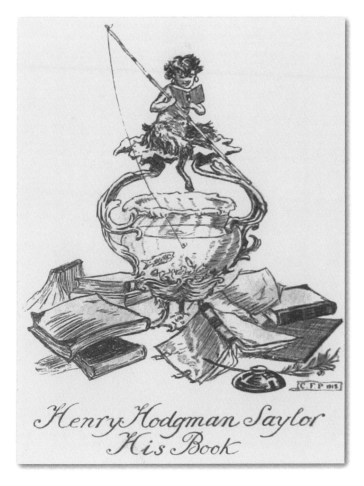

Henry Hodgman Saylor
His Book

HENRY HODGMAN SAYLOR
American (Dates unknown)
Evidently an enthusiastic angler, Saylor must have been greatly amused by the design of this bookplate. He is depicted as the Greek god Pan—half man, half goat—seen here perched on the edge of an elaborate see-through soup tureen-cum-fishbowl, his fishing rod dangling loosely in one hand while he holds a book in the other. While he was a book lover and a writer, little else is known about his life. We do know that he was a member of The Century Association and was well connected enough to have corresponded with Theodore Roosevelt.

ARTHUR MEIER SCHLESINGER
American (1888-1965)
*In this allegorical bookplate, which belonged to a respected American writer
and historian, the march of history is alluded to. An immigrant family is
pictured as it pauses a moment to ponder the future. The vista beyond
represents the future, with an agrarian society clearly making way for an
industrialized one, culminating with the modern city off in the distance.*

Margot Schmitz
German (Dates unknown)

This whimsical ex libris was commissioned by Margot Schmitz, a book collector from Cologne with an interest in festivals and carnivals. Designed by V. Kacivecks, an artist from the Czech republic, the bookplate depicts a group of costumed revelers. Venice is seen in the distance across the expanse of the bay. The words Ex Libris and the owner's name—written large in the sky above—fade away over the horizon.

IRENE AND DAVID OLIVER SELZNICK
American
David Selznick (1902-1965) Irene Mayer Selznick (1907-1990)
A formidable Hollywood couple, the Selznicks were dominant forces in the entertainment world. David Selznick's film credits include King Kong, A Star Is Born, Rebecca, Anna Karenina, *and, of course,* Gone With the Wind. *Irene Selznick, daughter of Louis B. Mayer, the legendary pioneer of the movie industry, grew up in Hollywood. Yet, after her divorce from Selznick she left the West Coast for New York and became a successful producer. Her Broadway hits include* A Streetcar Named Desire *and* Bell, Book and Candle. *While they were together, the couple lived in grand style—their bookplate attests to the comforts of home.*

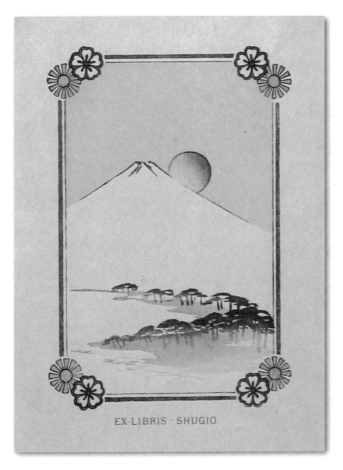

EX-LIBRIS · SHUGIO

SHUGIO [HIROMICHI]
Japanese (Dates unknown)

Many New Yorkers were first introduced to Japanese wood-block prints as early as 1889 when Shugio Hiromichi, director of the First Japanese Manufacturing and Trading Company, curated an exhibition of ukiyo-e ("pictures of the floating world"). These colorful prints and posters representing urban and pastoral pleasures were lyrical and contemplative, like this peaceful scene on his bookplate. A Japanese importer of porcelain and parasols, Shugio also contributed to the popularity of Japanese art among America's prosperous Gilded Age families, such as the Vanderbilts and Havemeyers.

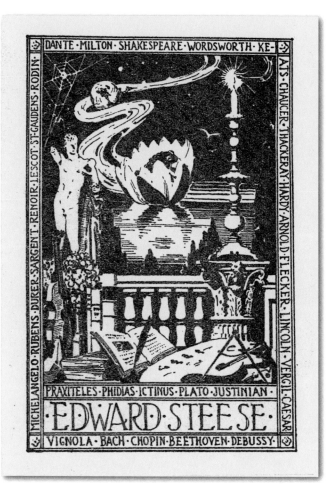

The bookplate border reads:

DANTE · MILTON · SHAKESPEARE · WORDSWORTH · KE-

KEATS · CHAUCER · THACKERAY · HARDY · ARNOLD · FLECKER · LINCOLN · VERGIL · CAESAR

MICHELANGELO · RUBENS · DÜRER · SARGENT · RENOIR · LESCOT · ST-GAUDENS · RODIN

PRAXITELES · PHIDIAS · ICTINUS · PLATO · JUSTINIAN ·

· EDWARD · STEESE ·

VIGNOLA · BACH · CHOPIN · BEETHOVEN · DEBUSSY ·

EDWARD STEESE
(Nationality and dates unknown)

Steese's bookplate, with its personal iconography—a lotus flower floating in the middle of a lake, a marble statue, a candle, a cobweb, a galaxy swirling around a planet, an open book, a compass—is difficult to interpret. But the list of artists, composers, writers, and philosophers surrounding the images tells us that the reader was thoroughly devoted to the arts.

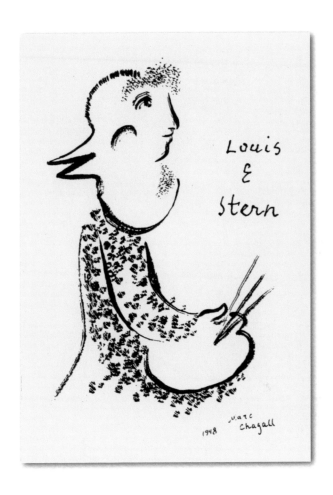

Louis E. Stern
American (1886-1962)
Marc Chagall designed this bookplate for his longtime supporter Louis E. Stern. Stern, a noted New York collector of books and artworks, must have been thrilled at the light-hearted, role-reversing caricature of himself as a young painter, poised to begin a new masterpiece.

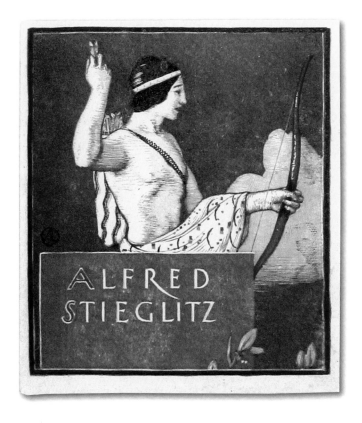

Alfred Stieglitz
American (1864-1946)

A true pioneer in the field of photography, Stieglitz is responsible for raising photography to an art form. One of the founders of the Photo-Secession, a group of avant-garde photographers, he later directed the Photo-Secession gallery at 291 Fifth Avenue in New York. This visionary gallery, often referred to simply as 291, showed the work of contemporary photographers as well as such painters as Picasso, Matisse, and Toulouse-Lautrec. The figure on his ex libris—a stylized version of a Native American—is about to draw an arrow from his quiver. Perhaps Stieglitz liked the allegorical comparison between himself and the "true" pioneers of the New World. Perhaps it symbolizes the moment when he "started my fight . . . for the recognition of photography as a new medium of expression, to be respected in its own right, on the same basis as any other art form."

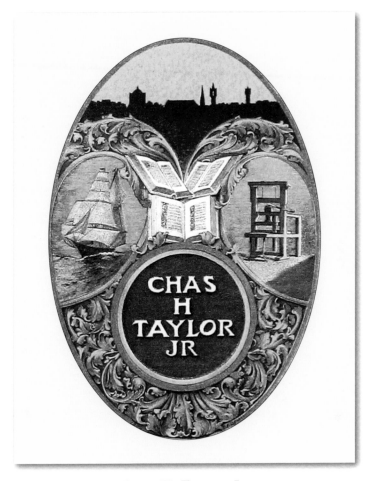

CHAS. H. TAYLOR, JR.
(Nationality and dates unknown)

While the identity of Taylor is unknown, there are a few things we can surmise. He was clearly a lover of books, as evidenced by the printing press to the right of the plate. Perhaps this passion was encouraged at Harvard, as the three books in the center offer an abstraction of the university's shield. While the rest of this plate remains a mystery—what is the city depicted at the top, and what is the significance of the old sailing ship?— Taylor leaves traces of his identity behind, a puzzle waiting to be solved.

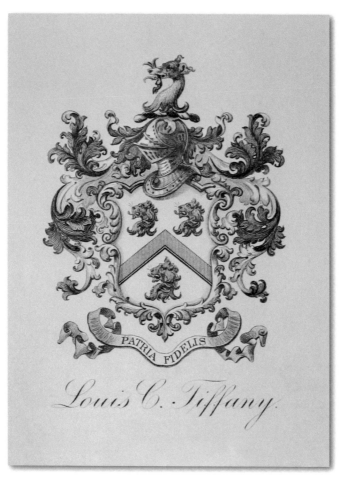

LOUIS COMFORT TIFFANY
American (1848-1933)

A magnificent example of a Chippendale-style armorial bookplate, this design presents the Tiffany family's coat of arms, including a shield with three lion heads and a helmet surmounted by a hunting dog. Best known for the shimmering iridescent Favrile Glass created in his famous studios, Tiffany was also a gifted painter. His landscape scenes, painted during his travels all over the world, have a quiet charm quite unlike the elaborately decorative glass lamps and stained glass windows for which he is so famous.

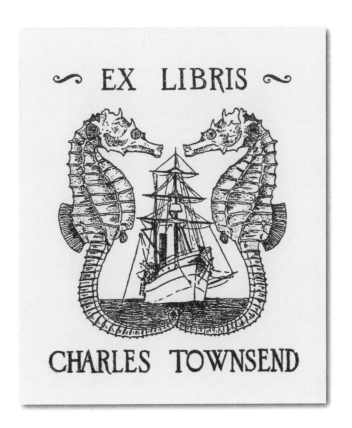

CHARLES H. TOWNSEND
American (1859-1944)

A noted naturalist and author, Townsend served as acting director of the
American Museum of Natural History and director of the New York Aquarium. He
participated in many scientific expeditions around the world. His ex libris depicts
the U.S.S. Albatross—reputedly the first vessel designed especially for research on
marine life—dredging deep beneath the sea. The ship is bracketed by two seahorses,
which are based on the terra-cotta design above the entrance to the aquarium.

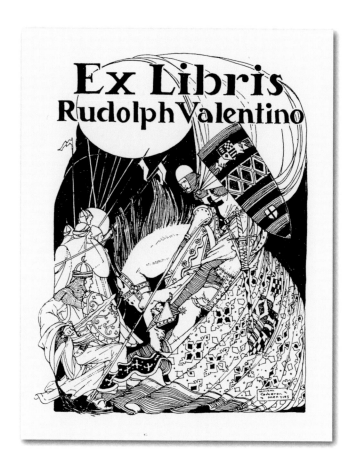

RUDOLPH VALENTINO
American (1895-1926)

Valentino was one of Hollywood's first screen idols. His appearances in silent films such as The Sheik *and* Four Horsemen of the Apocalypse *made movie audiences swoon with delight. Filmdom's ultimate Latin lover, Valentino had a worldwide following, and his death at age thirty-one caused mass hysteria as millions of devoted fans mourned. That the swashbuckling Valentino would choose action-packed and melodramatic imagery for his bookplate is no surprise. Here the hero prepares for battle, with a swoosh of his cape and some quick swordplay, much like the movie heroes that Valentino portrayed with relish.*

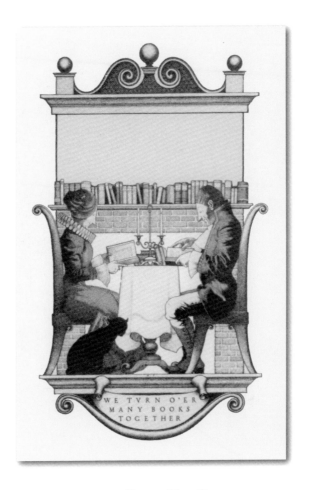

WE TVRN O'ER
MANY BOOKS
TOGETHER

JOHN AND ETHEL VAN DERLIP
American
John Van Derlip (1860-1935) Ethel Van Derlip (Dates unknown)
John Van Derlip was one of the founders of the Minneapolis Institute of Arts. He and his wife were dedicated book collectors and art enthusiasts, who in 1899 commissioned Maxfield Parrish (1870-1966), a well-known American illustrator, to create this bookplate. Rendered in Parrish's distinctive pictorial style, it is a slightly revised version of his 1887 cover of Harper's Weekly, *which showed a similar couple enjoying their Christmas dinner rather than reading books.*

HAROLD STEARNS VAUGHAN, M.D.
American (1876-1969)

Harold Stearns Vaughan reveals much about his life in the remarkably detailed vignettes on his ex libris. A surgeon by profession, he was also an accomplished sportsman. His love of golf and fishing are obvious, and we presume that he was also a talented horseman. The central image of a man reading most likely represents Vaughan himself. A man of many interests, he seems to have led a full life, though he might have preferred time spent in quiet contemplation, with a good book for company.

Queen Victoria
British (1819-1901)

Handsome armorial bookplates were designed for each member of the British royal family. This one dates from the late nineteenth century and was executed by Mary Ayfield. The initials VR stand for Victoria Regina, the long-reigning Queen Victoria, whose rule witnessed the expansion of the British Empire and a time of great prosperity known as the Victorian Age. The design includes the royal coat of arms atop a bed of roses, shamrocks, and thistle, which represent England, Ireland, and Scotland. The motto "Honi soit qui mal y pense," partially concealed by the crown and shield, is taken from the Order of the Garter, founded by Victoria's illustrious ancestor, King Edward III, circa 1344. It translates, "Evil be to him who evil thinks."

Justine and Walter Wanger
American
Walter Wanger (1894-1968) Justine Johnston Wanger (Dates unknown)

Justine and Walter Wanger certainly led colorful and interesting lives. He was the notoriously hotheaded producer of many legendary films. After a brief career as a silent film actress, Justine returned to medical school and was part of the team to develop the intravenous drip. In this bookplate we can see a rare moment of stillness and reflection in their lives, as the landscape of the American West is so serenely captured.

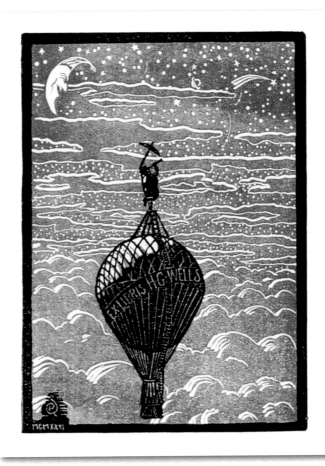

H. G. WELLS
English (1866-1946)

Wells was an English novelist, journalist, and historian. He wrote over one hundred books, half of them novels and many of them science fiction. His most famous is perhaps The War of the Worlds *(1898). In it he wrote, "No one would have believed . . . that human affairs were being watched keenly and closely by intelligences greater than man's and yet as mortal as his own; that as men busied themselves about their affairs they were scrutinized and studied, perhaps almost as narrowly as a man with a microscope. . . ." In this bookplate we can see a hopeful figure atop a hot air balloon with his telescope focused on the star-filled sky, trying to catch a glimpse of the "intelligences" that so fascinated Wells and his legions of readers.*

STANFORD WHITE
American (1853-1906)

A gifted draftsman and partner in McKim, Mead & White, America's most prestigious architectural firm during the Gilded Age, White was also a notorious womanizer and lavish entertainer. His scandalous affair with the beautiful former chorus girl Evelyn Nesbit led to his premature death at the hands of her jealous husband, Harry Thaw. Thaw shot the unsuspecting White on the roof of Madison Square Garden, a building White had designed only a few years before. White's ex libris, designed by Allen Lewis (1873-1957), is spare and understated, yet as elegant as the many Renaissance revival buildings he designed. A laurel wreath symbolizing achievement, a lion's head for strength, and the basic tools of his trade are succinctly combined in this perfectly balanced work of art.

JOHN HAY WHITNEY
American (1904-1982)
A well-known public official, newspaper publisher, and philanthropist, John Hay Whitney was also an outstanding polo player and expert horseman. He operated a breeding farm in Kentucky and owned many fine racehorses. Though he had an active career in business and in various government posts, eventually serving as ambassador to Great Britain, his enduring passion, reflected in this Rockwell Kent bookplate, was for horseracing.

Kaiser Wilhelm II
German (1859-1941)

The last emperor of Germany, Wilhelm was a highly militaristic leader. Commander in chief of the German armed forces throughout World War I, he was forced to abdicate his throne in 1918 in accordance with the terms of the armistice. His ex libris, designed in 1896 by Emil Doepler (1855-1922), is a tour de force of Germanic heraldry. An elaborate composition, lavishly delineated, it includes the German eagle on a shield, the royal crown, and Wilhelm's ornate jeweled necklace with Maltese cross. Handsomely bound leather books from the royal library—again decorated with the German eagle—frame the emperor's motto, "Imperatoris Regis."

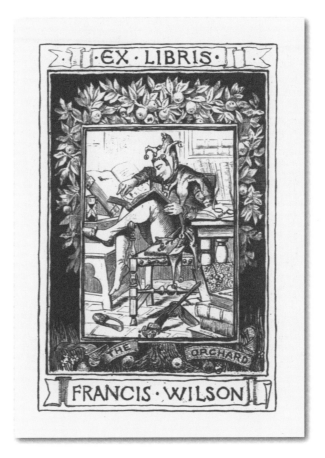

Francis Wilson
American (1854-1935)

A well-known professional in theater and minstrel companies, Francis Wilson began his stage career in Philadelphia and later specialized in comic opera. Here he sits, in jester's costume, reading a favorite book, enjoying the calm of his country home, The Orchard, which is represented by fruit interwoven with lush foliage encircling the top of the scene. In 1913 Wilson became the first president of the newly founded Actors' Equity Association, which to this day serves professional actors and stage managers.

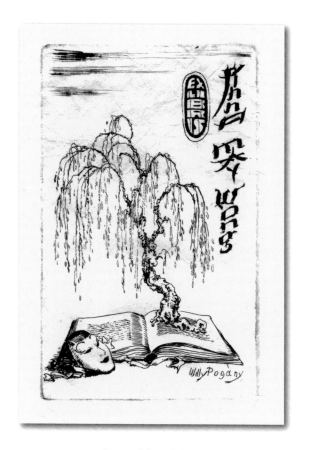

ANNA MAY WONG
American (1905-1961)

Best known for her starring role as the Mongol slave in the 1924 film, The Thief of Bagdad, *Chinese American actress Anna May Wong is remembered for her silent film classics. She was introduced to the American audience in* The Toll of the Sea *(1922), the first Technicolor feature film made in Hollywood. Her large almond-shaped eyes, rosebud mouth, and delicate physique created an instant sensation. Her bookplate, designed by Hungarian-born American artist, Willy Pogany (1882-1955), with its references to her Chinese heritage and willowlike figure—in the calligraphic lettering and willow tree rendered in the style of a Chinese brush painting—is a masterpiece of simplicity. In addition to working as an illustrator and book designer, Pogany was an art director in Hollywood, where he presumably met the famous film star.*

IF, **AFTER READING THIS BOOK**, you are interested in learning more about bookplates and bookplate collecting, there are many resources that can be tapped.

The American Society of Bookplate Collectors & Designers, not only provides a forum for collectors but is also concerned with educating the general public about bookplates and bookplate collecting. Founded in 1922, the society organizes traveling exhibitions and regional meetings, maintains a Web site (www.bookplate.org), and publishes a quarterly journal and the *Year Book* for members. Today the society is based in Cambridge, Massachusetts, with membership numbering more than a hundred and fifty individuals and fifty institutions. Its mission is "to cultivate the spirit of friendship and mutual helpfulness among collectors and designers of bookplates; and to assist in the further development of the bookplate." In addition the society corresponds and exchanges publications with many ex libris associations around the world.

Of course, it is not necessary to be a celebrity or even a wealthy person to commission your own personalized ex libris. With a modest investment and a bit of research you can commission or produce your own design that is a reflection of who you are. And if you are interested in collecting, there are many opportunities to learn about the history of bookplates, which have so succinctly provided a mirror of the times for over five hundred years. The only prerequisite is a love of books.

Assistance and information are available by contacting:
AMERICAN SOCIETY OF
BOOKPLATE COLLECTORS & DESIGNERS
Post Office Box 380340
Cambridge, MA USA 02238-0340
exlibrisusa@hotmail.com
exlibris@att.net
www.bookplate.org

Index

Selected Bibliography

Allen, Charles Dexter. *American Book-Plates: A Guide to Their Study with Examples.* Macmillan and Co., New York, 1894.

Arellanes, Audrey Spencer. *Bookplates: A Selected Annotated Bibliography of the Periodical Literature.* Gale Research, Detroit, 1971.

Butler, William E. *American Bookplates.* Primrose Hill Press, London, 2000.

Butler, William E., and Darlene J. *The Golden Era of American Bookplate Design: 1890-1940.* The Bookplate Society, London, and Forlaget Exlibristen, Frederikshavn, Denmark, 1986.

Cooney, Roy. "Bookplates Engraved on Copper," *Ex Libris Chronicle: The International Collector.* Volume 1, Number 2. ASBC&D, Cambridge Bookplate, Cambridge, MA, Autumn 2001.

De La Torre Villar, Ernesto. *Ex Libris y Marcas de Fuego.* Universidad Nacional Autónoma de México, México, D.F., 1994.

Jones, Louise Seymour. *The Human Side of Bookplates.* The Ward Ritchie Press, Los Angeles, CA, 1951.

Johnson, Fridolf. "The Art of the Bookplate," *American Artist.* Volume 29, Number 5. New York, May 1965.

Johnson, Fridolf. *A Treasury of Bookplates from the Renaissance to the Present.* Dover Publications, New York, 1977.

Keenan, James P., and Davis, Jacqueline E. *American Artists of the Bookplate: 1970-1990.* Cambridge Bookplate, Cambridge, MA, 1990.

Keenan, James P., and Davis, Jacqueline E. "Bookplates—A Modern Graphic Art Form," *Antiquarian Bookman: Bookman's Weekly.* Volume 88, Number 4. Clifton, NJ, July 22, 1991.

Keenan, James P. *American Artists of the Bookplate.* Cambridge Bookplate, Cambridge, MA, 1994.

Keenan, James P. Martin. "Baeyens: Innovative Expression," *Ex Libris Chronicle: The International Collector*. Volume 1, Number 3. ASBC&D, Cambridge Bookplate, Cambridge, MA, Winter 2002.

Kronhausen, Eberhard and Phyllis. *Erotic Bookplates*. Bell Publishing Company, New York, 1970.

Kulmeshkenov, Serik. "Light House of My Life," *Ex Libris Chronicle: The International Collector*. Volume 1, Number 4. ASBC&D, Cambridge Bookplate, Cambridge, MA, Spring-Summer 2002.

Marsboom, Filip, and Rousseau, Antoine. *Frank-Ivo Van Damme: Inspired Master of Flemish Exlibris*. Belgium, 1988.

Parfit, Cliff. *Exlibris Japan*. The Nippon Exlibris Association, Tokyo, 1982.

Parfit, Cliff. *Golden Age Exlibris: Graphics of the Art Nouveau and Art Deco Periods*. The Nippon Exlibris Association and Nippon Koshotsushinsha Ltd., Tokyo, 1996.

Parfit, Cliff. "Katsue Inoue," *Ex Libris Chronicle: The International Collector*. Volume 2, Number 2. ASBC&D, Cambridge Bookplate, Cambridge, MA, Winter 2003.

Roberts, Don. *Rockwell Kent: The Art of the Bookplate*. Fair Oaks Press, San Francisco, CA, 2003.

Rodel, Klaus. *Royal Swedish Super Ex Libris*. ASBC&D, Cambridge Bookplate, Cambridge, MA, 2000.

Severin, Mark F. *Making a Bookplate*. Studio Publications, London & New York, 1949.

Acknowledgments

The author acknowledges with gratitude the encouragement and support of the members of the American Society of Bookplate Collectors & Designers, and of Audrey Spencer Arellanes, the former director of the society.

With thanks to Lewis Jaffe and Richard Schimmelpfeng for their editorial comments and for contributing fine examples of bookplates owned by famous people. And with special thanks to Concepcion Elvira Provenzal for her knowledge and expertise in compiling the material for this edition. Richard J. Berenson is responsible for the handsome design and Margaret Mathews-Berenson contributed her editorial expertise, making this project a pleasure from start to finish.

The kind assistance of staff from a variety of institutions is also much appreciated: Roberta Waddell, Margaret Glover, and Nicole Simpson in the Print Collection of the New York Public Library, Miriam and Ira D. Wallach Division of Art, Prints, and Photographs; J. Fernando Peña, Cataloger, The Grolier Club; Jonathan P. Harding, Curator, and Russell Flinchum, Archivist, The Century Association Archives Foundation, and Bruno Quinson, also of The Century Association; David Platzker, Director, Printed Matter, Inc; Christine Nelson, Curator of Literary and Historical Manuscripts, The Morgan Library. Finally, special gratitude to Amy Wilson who contributed her talents for research and attention to countless administrative details throughout this project.

CREDITS

American Bookplates, by C.D. Allen: 19,

American Society of Bookplate Collectors and Designers: 10, 11, 12, 15, 16, 17, 18, 22, 23, 24 (Greenaway), 25 (Baskin), 28, 32, 33, 34, 40, 42, 43, 44, 45, 46, 51, 54, 55, 56, 57, 59 (Davis), 60, 62, 65, 71, 74, 78, 89, 90, 91, 92, 96, 101, 103, 107, 109, 112, 113, 116, 118, 120, 122, 123, 125, 127 (Bookman), 129, 130, 132, 139, 146, 147, 148, 151, 156, 159, 160, 161, 165, 166

The Century Association: 39, 59 (Baker), 70, 100, 119, 124, 126 (Seyrig), 133, 138, 140, 143, 145, 150, 154, 155, 158, 162

Department of Special Collections of the University Libraries
 of Notre Dame: 67, 77, 84, 97, 102, 105

Dover Publications, Inc.: 20, 37, 41, 53, 59 (Pembury), 64, 115, 128, 131, 141, 164

The Grolier Club: 7, 13, 21, 35, 36, 38, 47, 48, 50, 52, 58, 59 (Macy), 61, 63, 66, 68-69, 72, 73, 76, 79, 80, 81, 82, 83, 85, 87, 88, 93, 94, 98, 106, 108, 111, 114, 117, 121, 126 (Holstein), 127 (Wyncoop), 128, 134, 136, 137, 142, 143, 144, 149, 152, 153

Harry Ransom Humanities Center, The University of Texas at Austin: 104

James P. Keenan: 95

The Minneapolis Institute of Arts, Bequest of John R. Van Derlip
 in memory of Ethel Morrison Van Derlip: 157

The Poetry/Rare Books Collection, SUNY at Buffalo: 135

The Print Collection of The New York Public Library,
 Miriam and Ira D. Wallach Division of Art, Prints, and Photographs:
 75, 86, 99, 109, 110, 127 (E. and J. Diamond), 163

Printed Matter, Inc.: 26

Sotheby's Auction Catalog, Munich 2003: 25 (Kokoschka)